R.F.D. Country!
Mailboxes and Post Offices
of Rural America

14272 11/93

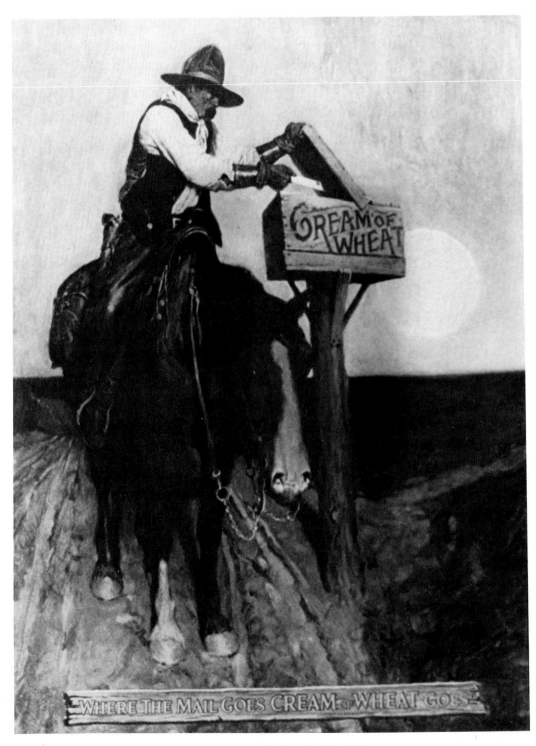

Artist N.C. Wyeth painted this famous "Cream of Wheat" ad in 1906.

R.F.D. Country!
Mailboxes and Post Offices of Rural America

Foreword by U.S. Postmaster General Preston R. Tisch
Bill and Sarah Thornbrook

West Chester, Pennsylvania 19380

Copyright © 1988 by William A. Turnbaugh and Sarah R. Peabody Turnbaugh.
Library of Congress Catalog Number: 87-63477.

Turnbaugh, William Arthur.
 R.F.D. Country! Mailboxes and Post Offices of Rural America.

 Bibliography: p. 16.
 1. Americana. 2. Folk Art—United States. 3. Postal Service—United States—History. I. Turnbaugh (pseudonym Thornbrook), William A. II. Turnbaugh (pseudonym Thornbrook), Sarah R.P. III. Title.
ISBN: 0-88740-121-X

Printed in the United States of America.
Published by Schiffer Publishing, Ltd.
This book may be purchased from the publisher.
Please include $2.00 postage.
Try your bookstore first.

4

Contents

Foreword

Mankind has carried into modern times an impulse for self-expression that first manifested itself in the earliest days of human existence. Through their creativity and imagination, archaeologists have been able to reconstruct what primitive life was like. In this day and age, television, photographs, paintings, tapestries, advertising, catalogues, newspapers, books and magazines and industrial art of all types have taken the place of cave drawings, clay vessels and stone weapons as reflections of our life styles and values.

Small wonder, then, that we still cherish the picturesque country post offices and individualized mail receptacles that play such an important part in our otherwise sophisticated national mail system.

Whereas earliest man could draw a buffalo on the wall of a cave he called "home," modern man has to cope with a Postal Service providing guidelines within which his imagination must work. Today's RFD customer must first request permission to stray from the conventional, then meet specific size and placement rules—some required by the Postal Service, others by local and state laws.

It is all the more remarkable, then, that we still find the time and the ability to be creative—to add that very personal touch to that most routine of everyday services—the rural mail box.

The box-owner's willingness to conform with delivery and safety regulations and still create an unusual receptacle for his mail shows passers-by man's strong drive for self-expression. How great, too, that we now have a chance to sit back and reflect on the spirit captured in these words and pictures.

Preston R. Tisch
The Postmaster General

Preface

Over the years we have criss-crossed the country many times on vacation and research trips. Motorists who wish to get from place to place in the least time and with a ready availability of fuel, food and accommodations find the interstate highways to be marvelous conveyors, efficiently engineered and convenient. But we follow the secondary routes as much as possible. They offer the chance to experience America from a front-row seat.

The sight of an unusual mailbox erected along a rural road is but one small bonus that comes with this close-up view. Initially, we didn't plan to write a book on the topic. In fact, we realized only gradually that the creative boxes are really an expression of folk art. One day we photographed a few of them. We began to take more notice as we drove along after that. Soon our heads snapped instinctively toward upcoming letterboxes. We had to agree that our new hobby was becoming a quest! Frequent stops to take another postal portrait gave our travelling a lurching, spasmodic quality. We sought out boxes along Rural Free Delivery (R.F.D.) mail routes deliberately now, following likely looking roads and even planning trips to include some unexplored areas.

The result is this sampler of R.F.D. boxes from nearly every state.

On any fishing expedition some of the best ones manage to get away. So it is here. Although we photographed in all kinds of weather, daylight frequently gave out before we did, and our camera was of little use in recording a mailbox at dusk. There were times when one of us didn't load the film properly. Occasionally the camera was forgotten at home. And more than once we got lost trying to follow an informant's directions to some renowned but remote receptacle. Of course, multitudes of spectacular mailboxes still exist out there beyond our reach.

How we wish we could see them all!

Bill and Sarah Thornbrook

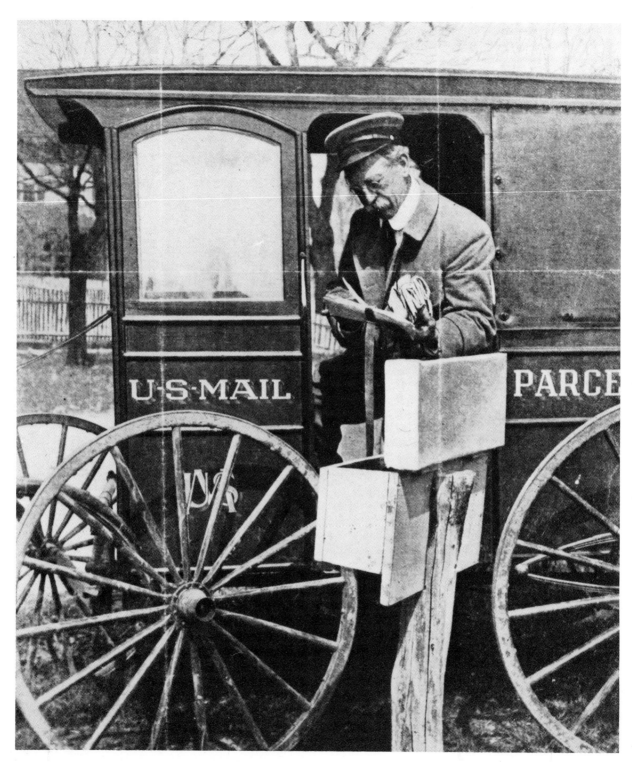

Making a delivery, 1916.

The Mail's Here!

Early American Postal Service

Puffs of vapor steamed from the Indian's flaring nostrils. The Narragansett's heaving chest testified to the speed with which he had come through that bleak February forest, bearing in his waistband the white man's talking paper. Now he stood before John Winthrop the Younger, leading citizen of the new settlers in the Connecticut River valley. The Governor took the paper, broke its wax seal, unfolded and read it hastily. He rose, indicating that the native should wait, and presently returned with half a dozen large metal needles. The Indian's face remained passive when he took them, but his eyes sparkled with satisfaction as he turned to leave.

Winthrop had paid the "postage" due on the letter from his correspondent, Roger Williams, spiritual and political leader of the neighboring colony of Rhode Island. Williams himself already had given his messenger six iron awl blades; his letter reminded Winthrop to do likewise when it came safely to his hands. Such was rural delivery in 1649.

Letters sent by ship between America and far-off England seemed almost more certain of delivery, despite weeks of sailing, than those addressed within the colonies. Few roads extended beyond the coast-bound settlements, and not many travellers challenged the seemingly trackless wilderness. Inconvenience and uncertainty characterized communications in colonial America. For most rural areas, the situation would change scarcely at all for several centuries.

English authorities failed to acknowledge the ineffectiveness of mail transport in the colonies. It was left to Americans themselves to devise ways of delivering messages and official documents to the inland towns or between the seats of government. Governor Winthrop himself was instrumental in developing the so-called Post Road linking New York and Boston in the late 17th century. The first post rider left the tip of Manhattan in January 1673, arriving just two weeks later in Boston, 250 miles across unbridged rivers and tangled countryside. The experiment had to be suspended when New York reverted to the Dutch, and Indian raids cut off New England. Consistent mail service between even principal colonial centers remained a long way off.

In the early 1700s the Crown initiated a formal colonial postal service, but it barely got organized until after the appointment of Alexander Spotswood, a former governor of Virginia, as the royal postmaster general for the colonies in 1730. During his nine years in office,

Spotswood made some contributions to better mail service, but none more important than his selection of Benjamin Franklin, publisher and inventor, as postmaster of Philadelphia. In 1753, Franklin became postmaster general for all the northern colonies and instituted some far-reaching improvements of his own. He oversaw the extension and upgrading of post roads, regulated the post riders, even introduced an overnight delivery service between New York and Philadelphia. And, he managed to return the first profits in American postal history.

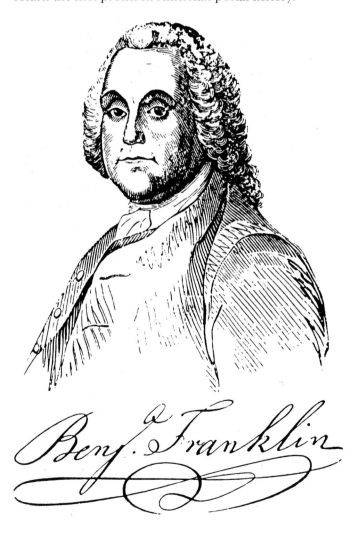

Postmaster General Benjamin Franklin

Thanks to Franklin's innovations, letters and news-papers from one city to another could at last be sent and received with some regularity. Improved communication linked the colonies just as many Americans were coming to resent their status as British subjects. Franklin himself, while still serving in his postal position, undertook important diplomatic missions to England right up to the eve of the Revolution, when he finally left his postmaster generalship.

Franklin thereupon became a delegate to the newly convened Continental Congress, a body that recognized the importance of the mails—and the folly of using the Royal post for what surely would be considered treasonous communiques. The new nation clearly needed its own postal system. His long experience made Benjamin Franklin the natural choice as postmaster general. But his talents were crucial elsewhere as well, so after serving a few months in 1776, Franklin relinquished the post to his son-in-law, William Bache.

The creation of a permanent national government following the Revolution included a postal system that incorporated most of Franklin's improvements. At first a branch of the Treasury Department, the Post Office soon gained independent status. The service remained pretty basic for many decades after Franklin's day. Mail travelled between post offices only; patrons had to present them-selves periodically to see if they had any letters waiting. In rural regions (and that included most of the country until the 20th century), the round trip over poor roads might require hours of travel. In some small post offices, the contents of incoming mailbags simply were dumped onto a table for anyone to rummage through. It was by no means certain that an article consigned to the U.S. Mail would get to its intended recipient in good time—or anytime.

Only in larger cities might customers avoid the inconvenience of journeying to the post office. At a charge of two cents per item, letters could be delivered to the home. Then, in July 1863 the Post Office instituted free city delivery. Letter carriers walked their appointed rounds for the first time, delivering mail in 49 cities, seven days a week, in all kinds of weather. The service was immediately popular with those who benefitted directly. But rural patrons began to call attention to their own unimproved situation. A few Washington officials, notably Congressmen representing rural districts, proposed extending free delivery into the countryside. But problems of cost and logistics became strong arguments against the idea. It was especially distasteful to many of the small-town postmasters, who foresaw the loss of their positions and the decline of the businesses they usually ran in conjunction with the post office.

There the matter rested until the administration of Postmaster General John Wanamaker (1889-1893). Much as Franklin had prepared the mail service for the 19th century, another Philadelphian pulled it toward the 20th. As proprietor of that city's largest emporium, Wanamaker followed the philosophy that the customer comes first. He felt the same way about the Post Office. Wanamaker was instrumental in creating parcel post, the postal savings system and railroad mail service. Most significantly, he did more than anyone else to make free mail delivery in rural America a reality.

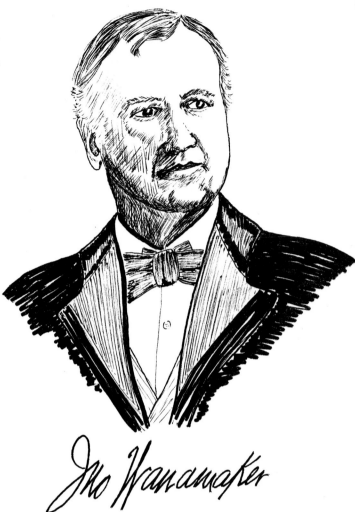

Postmaster General John Wanamaker

Faced with an antagonistic Congress and hostility from thousands of small town postmasters who felt threatened by changes, Wanamaker was not immediately able to achieve all he intended. Some of his creations were stalled until he was gone from office. One of these was Rural Free Delivery. Finally convinced of its value, Congress voted funds in 1893 for rural delivery, just as Wanamaker's term ended. The merchant's successors flatly refused to spend the appropriation for several years. At last, Postmaster General William L. Wilson reluctantly agreed to test the idea in his home state of West Virginia. On October 1, 1896, wagons laden with sorted mail set out from Halltown, Uvilla, and Charlestown to make the first rural deliveries.

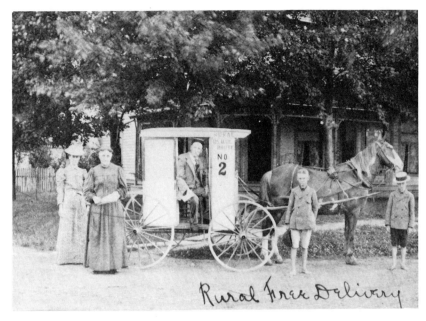

Turn of the century R.F.D. mail carrier, Indiana

Rural Free Delivery

Almost immediately, Rural Free Delivery was hailed widely as a great advance of civilization. The service seemed to testify to a beneficent government's concern for the more than half of the American population who yet lived down on the farm. Contemporary supporters applauded R.F.D.'s salutary effects on rural life, and probably exaggerated only slightly when citing its numerous and far-reaching social and economic benefits. They noted that more farm families were now able to receive and read daily newspapers and periodicals, thereby enhancing public education. Roads were improved and extended, encouraging the development of rural areas and even raising real estate values. Increased communication and information from the outside world reduced the monotony of farm life and encouraged young people to remain on the land. No longer under the necessity of travelling many miles once or twice a week to the post office in town, the farmer could spend his time more profitably—and was less likely to squander his money on notions at the village store or in the saloon. With an even broader perspective, some boosters proclaimed that the Rural Free Delivery system would reduce the nation's sectionalism, binding together North and South, East and West.

During the early days of the service, economy-minded postal officials in Washington, nervously eyeing the burgeoning cost of Rural Free Delivery, solicited comments from postal patrons concerning whether or not to continue the program. The response was overwhelmingly positive. Farmers quickly had grown accustomed to the daily arrival of the mail carrier. It was a convenience they would not now consent to lose. What's more, Congressmen representing rural areas were beseiged with petitions for new routes. So insistent were their constituents that only the most unastute of politicians delayed in forwarding these requests to postal headquarters along with a personal plea to expedite the process. More than one officeholder urged postal authorities to get the new routes into operation *before* the upcoming elections. Routes routinely were granted more quickly in those congressional districts whose representatives belonged to the party in power.

Beginning with those three routes in October 1896, the service counted 44 routes in 1897, boasted a thousand early in 1900, and reached 2551 by November 1 of that same year. Another 4517 route applications flooded the Department during the next four months alone. By 1902 nearly 8300 routes were in operation, and in 1920 the number stood at 43,445.

The expansion of R.F.D. correlated with a decline in the number of village post offices across the country. Many of these facilities had been located in tiny hamlets and crossroads villages, where a small grocery or

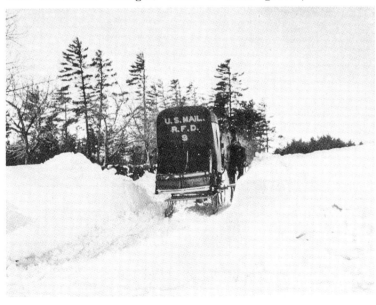

"Neither snow, nor rain...," Concord, New Hampshire, circa 1900

11

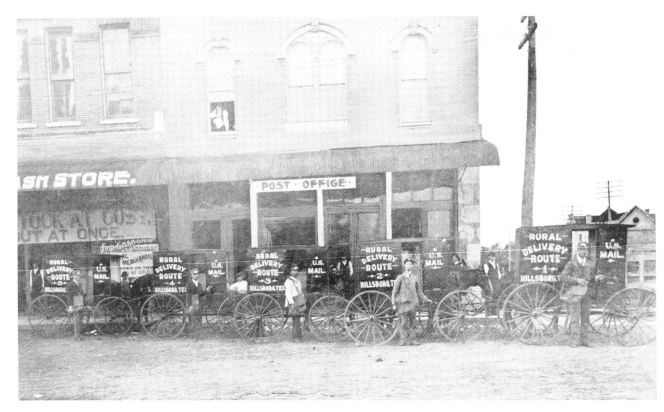

R.F.D. mail carriers, Hillsboro, Texas, circa 1900

mercantile store doubled as a U.S. Post Office. A small window or open counter, perhaps a scale, and a few postal boxes sat in one corner. It might remain there only so long as the same political party held power in Washington. An election reversal generally meant that another shopkeeper of the winning party received the postal appointment, and the equipment was forthwith moved to the new location. The postmaster/proprietor was entitled to keep the first $1000 in postal revenues. Those designated as "Fourth-Class" post offices (that is, reporting less than $5000 annual gross receipts) had numbered more than 70,000, out of a total postal system of 76,945 offices, in 1901. By 1920 this figure dropped to 41,102 with the closing of nearly 30,000 local postal offices eliminated by the success of R.F.D. Farmers found fewer reasons to come to town regularly. Trade fell off further because goods could be purchased through the new mail-order catalogs, with delivery directly to the home. Once their post offices closed, many small towns literally lost their identities and disappeared from the map.

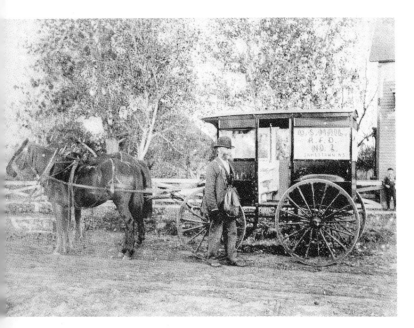

R.F.D. wagon, Jamestown, Kansas

The Rural Mailbox

In their selection of the family mailbox as in their choice of President, Americans proved to be capricious and individualistic. Early receptacles for the mail very often consisted of any handy container that could be perched or posted at the end of a farm lane or along a country road. The Postmaster General reported in 1897 on the random array of boxes that typically presented itself to rural carriers, using a Washington state example: "The 'boxes' are of sundry shapes, sizes and colors. One man has a lard pail hung out on a fence post; three or four have nailed up empty coal oil cans, and a few have utilized sirup cans....Old apple boxes, soapboxes, cigar boxes, and in one instance a wagon box, adorn the entrances to farms all over the valley." Another rural carrier encountered a sign beside a crack in a fence, requesting him to "Put the Male Hear." As a matter of fact, this technique did have its historical precedents. Early explorers and gold-seekers crossing the Great Plains frequently left messages on a scrap of paper or hide clamped in a split twig or forked stick along the trail. But this was now the 20th century and the official U.S. Mail, transported between sender and receiver with great purposefulness (and at considerable expense), deserved—nay, demanded—a suitable depository at the completion of its journey.

The minimal expectation was that the receptacle would be placed conveniently at the side of the road at a height that would enable the carrier to execute his transactions from the seat of his buggy. Beyond that, individuality ruled. From time to time the Post Office Department tried various approaches to improve and standardize the mailboxes on rural delivery routes. Nearby farmers came to a small Indiana town in the spring of 1900 to pick up boxes supplied by the government at a cost of $2.60 each. But apparently not everyone elected to obtain one of the special devices, choosing instead to supply their own in accordance with whim and the availability of empty tins or crates.

With the rapid expansion of mail routes the disorderly display of mailboxes became all the more vexing to postal authorities. Something had to be done. In 1902 Congress authorized the Postmaster General to "investigate the advisability of purchasing and adopting a uniform metal lock box at a price not to exceed fifty cents, for the purpose of selling the same to patrons on rural free-delivery routes at cost." Constituents in sufficient number promptly let their Congressmen know that they would not bear such an intrusion on their pocketbooks and on their freedom of choice as this 50-cent "uniform metal lock box" seemed to represent.

Continuing its quest for an ideal box that would be acceptable to the public, the Post Office next solicited samples from manufacturers and selected boxes of 14 companies as suitable. Farmers then were encouraged to purchase one of these receptacles. Those who did not were liable to open their own rickety substitute one day and find an official notice within: "The mailbox put up by you is not secure, not weatherproof. Within thirty days of this date you must supply one of the approved boxes enumerated on the reverse side of this card or your service will be withdrawn."

In response to charges of "Monopoly!" the Post Office soon modified its policy once more by setting general specifications for mailboxes and allowing any manufacturer to make and market devices that adhered to the standards. Boxes were to be of durable sheet metal construction, galvanized if possible, and weatherproof. They should measure at least six inches high and 18 inches long, whether of rectangular or cylindrical shape, and should open from the side or top. Each was to be fitted with an adjustable metal signal. One such box per family was to be erected by the roadside at a proper height.

A typical R.F.D. box answering this description was invented and manufactured by William S. Isham of Maple Hill, Kansas. His sturdy metal box was designed for the convenience of a driver seated in a wagon. It was a

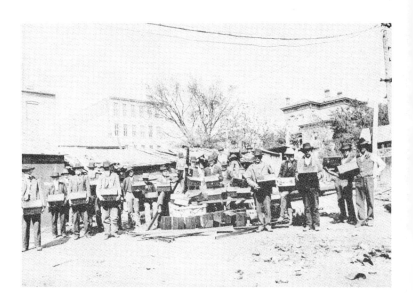

Farmers with their new mailboxes, Attica, Indiana, 1900

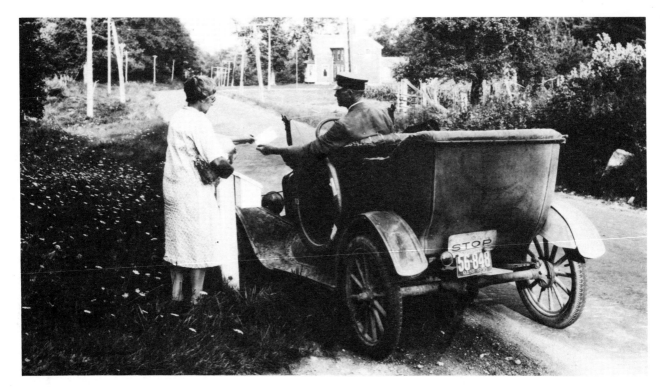

Delivering the mail in Maine, 1930

horizontal cylinder, sealed at both ends, its front-opening flap hinged at the top. Not all boxes were quite so practical in their design. One contemporary advertiser expressed the view that many of his competitors' mailboxes were "better fitted for rat-traps or puzzles for the insane."

Meanwhile, the Post Office Department persisted. Finally, in 1915, an engineer with the Department, Roy J. Joroleman, designed a tunnel-shaped metal box with a snap-close hinged front and movable flag. Joroleman's box looked to the future. It was well suited for use by rural carriers seated in automobiles, which were effectively replacing the horse-drawn buggy on the long rural routes. Postmaster General Albert Burleson gave Joroleman's design his official endorsement, and boxes manufactured to those specifications by private companies were entitled to bear the designation "Approved by the Postmaster General." In 1928 the Department extended official sanction to a larger version of the box, designed to accommodate parcels. By far, the most common rural delivery boxes in use even today are of the "Approved" style.

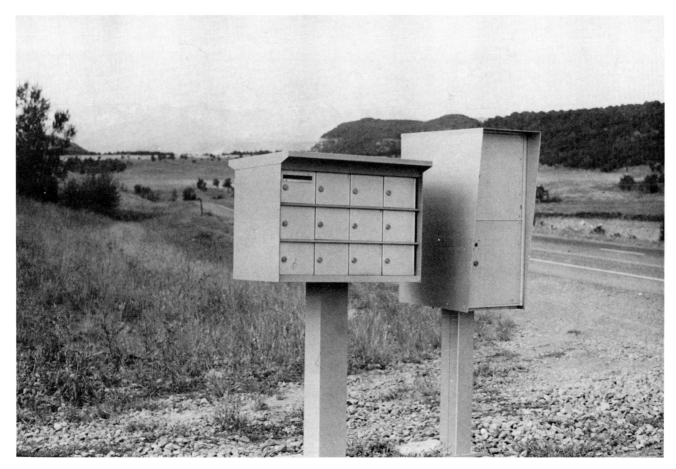

Modular mailboxes, Ouray County, Colorado

Tradition and Change

Though most postal customers probably are unaware of the fact, the individual rural delivery box, no matter how humble, comes under a host of Federal regulations. It is, in essence, *almost* Federal property. From the earliest days of R.F.D., isolated mailboxes along country roads attracted pranksters, and sometimes those of more serious criminal intent, resulting in damage or loss of mail. The government then as now considered mail-pilfering or interference with its delivery to be no minor offense. Yet, until mail receptacles were under Federal jurisdiction, prosecution was ineffective. So, by fiat, "every letterbox or other receptacle intended or used for the receipt or delivery of mail" became "an authorized depository for mail" and was thereby covered by a number of Federal laws that govern not only what may be put into such containers, but also set standards for their construction and appearance, and protect them against tampering or destruction.

The Postal Service sets sizes for traditional and more contemporary style boxes and publishes a list of approved manufacturers (there are 25 on the current list). The officially preferred color for rural boxes and their supports is white, but other colors are acceptable. More creative, non-traditional boxes on rural routes come under the authority of the local postmaster, who may approve them provided they conform to the principal requirements, are not designed as "effigies or caricatures that would tend to disparage or ridicule any person," and do not carry advertising. A patron who fails to maintain a rural box in conformity to regulations risks receiving the dreaded USPS Form 4056, "Your Mailbox Needs Attention."[1]

110 identical boxes, Mims, Florida

[1] Those wishing to construct or modify their own boxes may wish to obtain official guidelines from the Rural Delivery & Administration Division, Delivery Services Department, Operations Group, USPS Headquarters, Washington, D.C. 20260. Relevant regulations regarding rural receptacles are found in the *Domestic Mail Manual, 1986* (Sect. 151, 156) and the *Postal Laws* (18 USC, Sect. 1702, 1705, 1708, 1725).

Most of the receptacles lining rural delivery routes today are "Approved" style manufactured metal boxes of standard shape and sizes. But even in trailer parks or other instant communities, the initial uniformity seldom lasts for long. Most boxes soon acquire some individuality, and many come to reflect the families they serve. Some boxes tilt at a jaunty angle, while others seem almost to sag under their long years of service. Old dented boxes recall stick-wielding schoolboys walking from a bright yellow bus, or the time the hay wagon veered off the road to avoid the out-of-state Cadillac. Fingers of rust creep from the arched top, further obscuring the faded letters of a good neighbor's name. The small cluster of boxes in the swale and the single sentinel along the rise in the road mark the familiar landscape close to home in R.F.D. Country.

Few folks can long resist the urge to decorate that "standard" box, to make it something of their own. A name splashed in big blocky letters, or a fancy nameplate bolted to the top; a pretty dime-store decal, or a folksy emblem applied by a tentative artist using leftover housepaint—each is a way of saying "I live here!"

Support posts generally are not provided with the standard rural receptacle, so a glance beneath the mailbox may give a measure of the proprietor's resourcefulness. The object, of course, is simply to elevate the box to the appropriate level and then to keep it there, more or less steady, for as long as possible. Cinderblocks, stumps, leftover plumbing, old porch posts, rocks, antique farm implements, and original *objets d' art* share the noble task of holding up the U.S. Mail.

Some free-thinking Americans have abandoned tradition altogether. They ignore the "Approved" models as they set about creating their own unique mail containers. Admittedly, there are relatively few who start from scratch in expressing themselves. Post office officialdom mildly frowns on the do-it-yourself job, and, besides, a standard letterbox can lend itself to some pretty imaginative customization.

Unusual boxes often tend to cluster, punctuating long series of more ordinary containers along the roadside. Sometimes it appears that mailbox decorators inspire one another, and try to out-do the competition in the process. The approaches to small towns seem most productive of interesting boxes. The more remote country roads may not have enough passersby to repay the effort.

The R.F.D. mailbox, plain or fancy, can't yet be considered an endangered species, but its future is not secure. As the nation's population approaches a quarter of a billion people, the growth of both urban and suburban neighborhoods is filling in many rural areas. The number of post offices continues to decline as smaller stations are closed or consolidated. The figure now stands below 30,000, down from nearly 77,000 at the beginning of the century. At the same time, the demands on the postal system are greater than ever. In 1985, 73.8 million households and businesses in the U.S. received 140 billion pieces of mail. More than 35,000 rural carriers served 17.4 million addresses along some 2 million miles of routes.

With the current annual cost of mail delivery to each household estimated at $105 for door-to-door service and $83 for curb service, delivery is the most costly item in the postal budget. To cut down on this expense, the Postal Service is now installing a new form of mailbox, comprised of modular units grouped on a free-standing base. Several hundred thousand rural boxes already have been replaced in areas that can be served by more centralized delivery. The cost of bringing mail to these receptacles is a comparatively modest $53 per annum. It is likely the trend of eliminating individual rural boxes may accelerate.

Meanwhile, let us enjoy the many unusual and delightful creations that brighten the byways of R.F.D. Country!

For Further Reading

Cullinan, Gerald. 1973. *The U.S. Postal Service*. Frederick A. Praeger. New York, NY.

Fuller, Wayne E. 1964. *RFD: The Changing Face of Rural America*. Indiana University Press. Bloomington, IN.

———— 1972. *The American Mail: Enlarger of the Common Life*. University of Chicago Press. Chicago, IL.

Greathouse, Charles H. 1901. Free Delivery of Rural Mails. In, *Yearbook of the U.S. Department of Agriculture for 1900*. Government Printing Office. Washington, DC.

Scheele, Carl H. 1970. *Neither Snow, Nor Rain...The Story of the United States Mails*. Smithsonian Institution Press. Washington, DC.

———— 1970. *A Short History of the Mail Service*. Smithsonian Institution Press. Washington, DC.

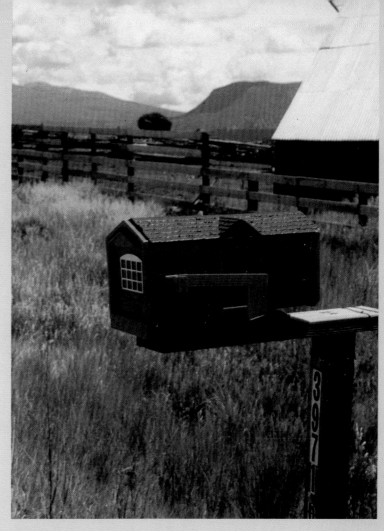

Plastic novelty boxes are replacing traditional forms, as seen near Mancos, Colorado.

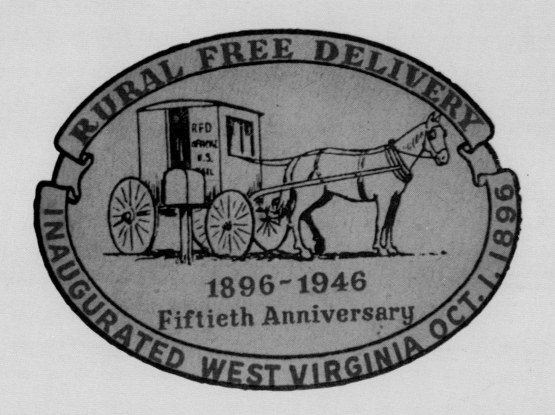

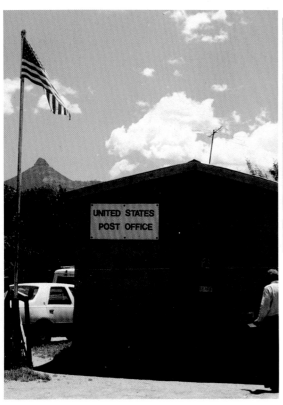

Mailing a letter in Youngsville, New Mexico

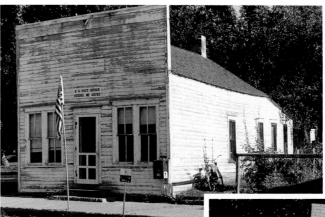

Some small towns in the West's ranching country still boast traditional "false front" post offices. **Above:** Verdel, Nebraska; **right:** Adin, California; **below right:** Chester, Oklahoma.

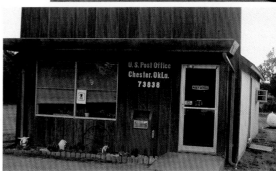

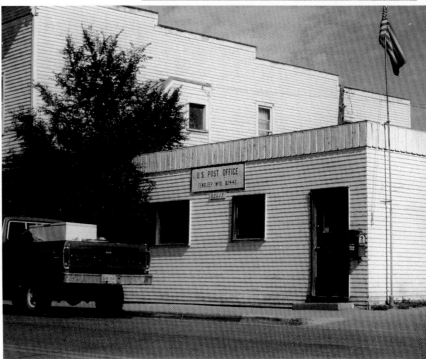

Lacey Spring, Virginia

Tensleep, Wyoming

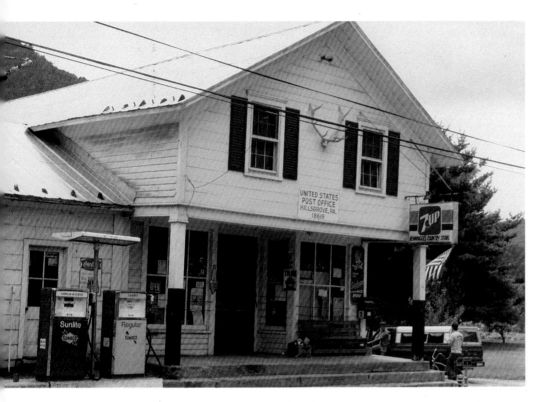

Rural post office and general store, Hillsgrove, Pennsylvania

Salute to the R.F.D. Post Offices!

R.F.D. post offices scattered throughout the country remain a symbol of what America once was—a nation of neighborhoods and farms and ranches. Though their numbers have decreased steadily in recent decades, their charm has not diminished.

Here and there, a tiny building dwarfed by an outsized flag rippling overhead continues to serve small numbers of postal patrons in some of the nation's most rural areas.

The post office at Muddy, Illinois, measures only 7½ feet by 10½ feet and is the smallest in a 10-state area, according to Postmaster Barbara N. Kassner. Within are 42 boxes; another 55 customers receive home delivery.

When it closed in February 1955, the office at De Luz, California (right), claimed to be the smallest in the entire nation.

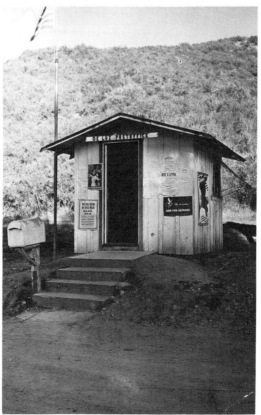

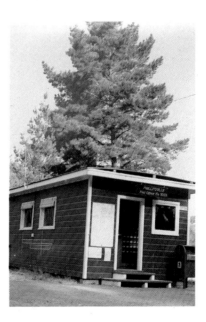

The Phillipsville post office (above), in California's redwood country, is one of the smallest still in use in the West.

19

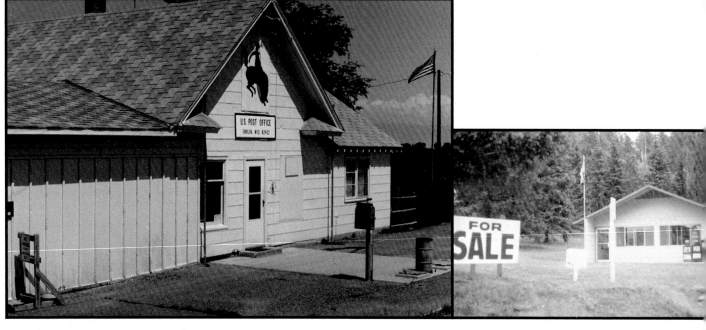

Like many others we noted in our travels, Emblem, Wyoming's, post office building *(left)* was for sale in 1986. The town's population of 10 will be getting their mail from a regional center miles away. *Right:* The office at Cascade, Colorado.

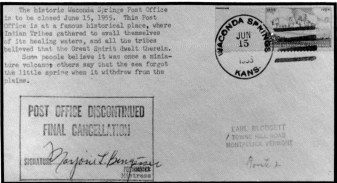

A few small offices, like Wakonda Springs, Kansas, *(left)* commemorated their sad final day of operation with a special cancellation.

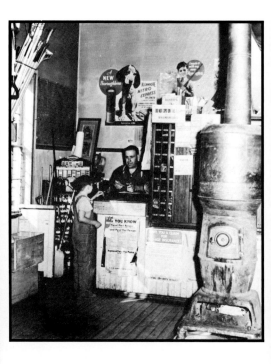

Thousands of other facilities, like this 1870's post office along Florida's Ocklawaha River *(below)*, disappeared long ago.

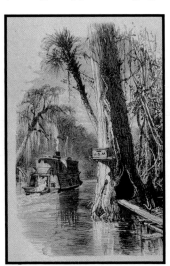

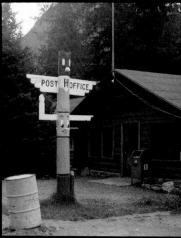

Small community post offices often operated from a corner of the general store, as in the photograph *(far right)* taken in Iowa in 1939. In a few places, they still exist. **Hillsgrove, Pennsylvania's**, general store/post office (p. 19) recalls the rural post offices of an earlier era. Most of its customers have done business there for a long time. **Herman's Trading Post** *(right)*, Silver Gate, Montana, serves visitors to nearby **Yellowstone National Park** as well as a handful of year-round residents.

20

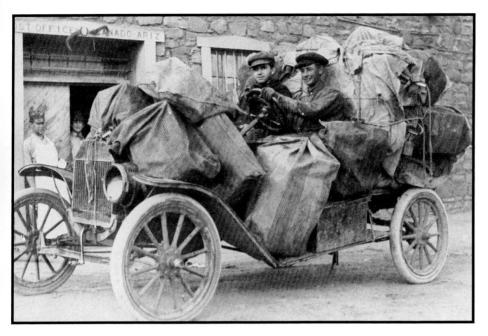

Above: J.L. Hubbell's Trading Post on the Navajo Indian Reservation, Ganado, Arizona, gave the local post office a lot of business in the 1920s. **Right:** The modern adobe post office on the Santo Domingo Pueblo Indian Reservation north of Santa Fe, New Mexico, is especially active when the afternoon mail arrives.

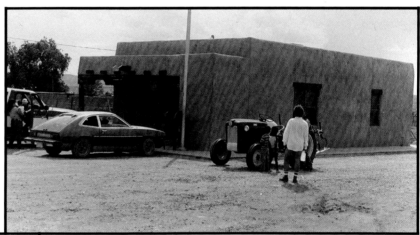

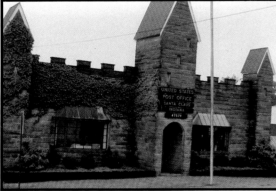

Some rural facilities process a larger volume of mail than the local population could possibly generate on its own. Christmas, Florida *(right)*; Santa Claus, Indiana *(above)*; Valentine, Nebraska; Loveland, Colorado; and a few others reach seasonal peaks that require extra hands to process all the holiday letters addressed to the local postmaster for re-mailing to the senders' friends and relatives.

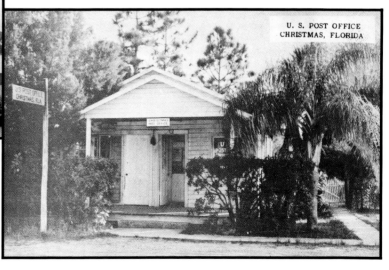

21

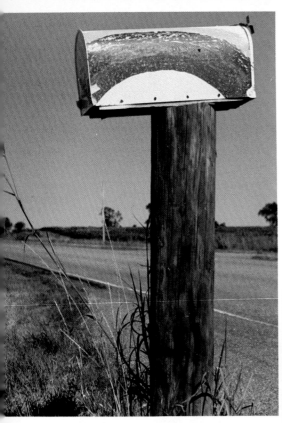

America's mailboxes come in a rainbow of colors!

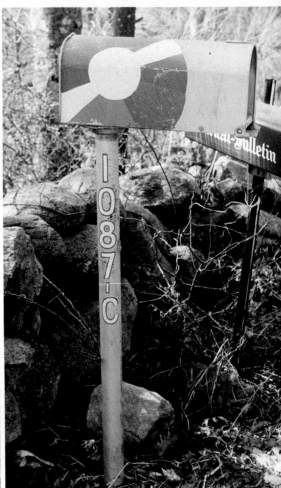

East of Crofton, Nebraska

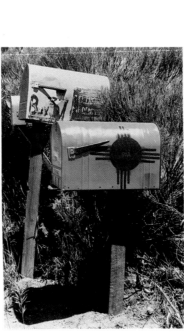

Color wheel, Perryville, Rhode Island

Peyton, Colorado

Zia sun, east of Taos, New Mexico

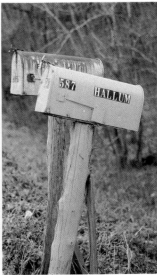

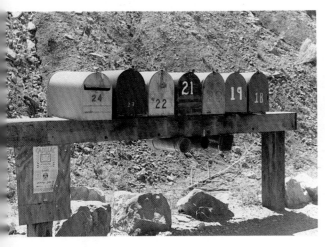

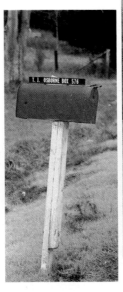

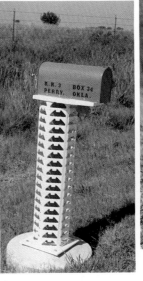

Yellow... Morganville, Georgia

Rainbow row, Sandia Mountain Road, New Mexico

Red... North of Trenton, Georgia

Orange... Perry, Oklahoma

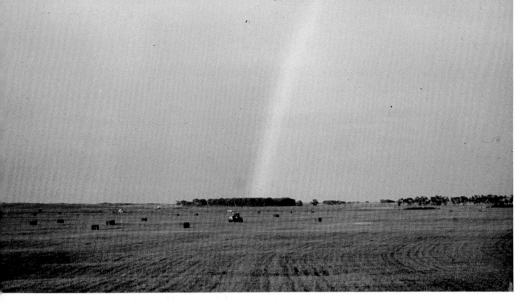

Rainbow over hay ranch, north central Nebraska

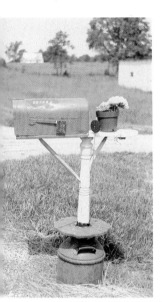

Green... West of Nevada, Missouri

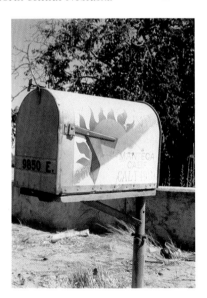

Partly sunny, Manteca, California

Follow the Rainbow!

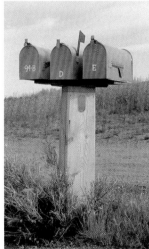

Blue... Santa Fe, New Mexico

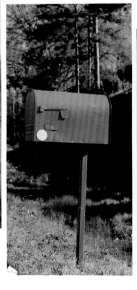

Indigo... Heidelberg, Mississippi

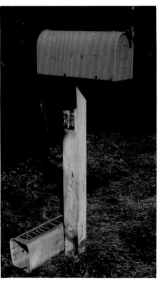

Violet. Big Flats, New York

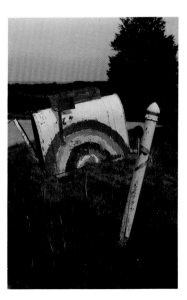

Sometimes the whole spectrum comes together on one box! Spring Green, Wisconsin

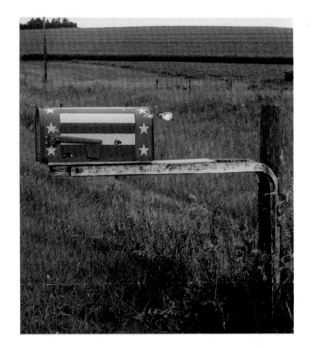

Inwood, Iowa

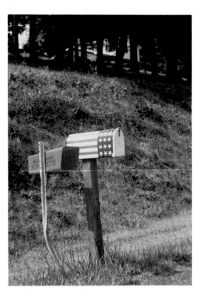 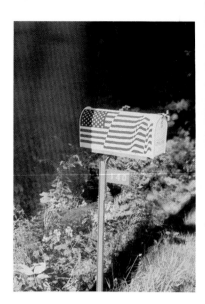

Above *(left, right):* Flag boxes at Balls Mills, Pennsylvania, and Putnam, Connecticut.

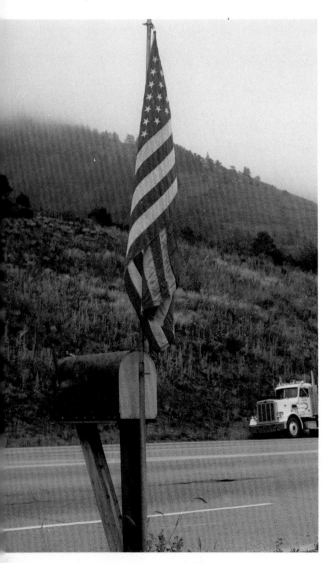

American flag flies over mailbox on flanks of Pikes Peak, Chipita Park, Colorado.

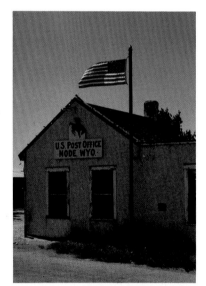 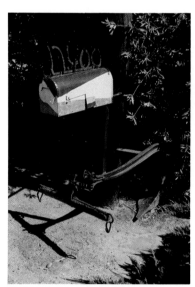

Above *(left, right)* Old Glory unfurls over the post office in Node, Wyoming. Painted box and horseshoes atop an old plow, Escalon, California.

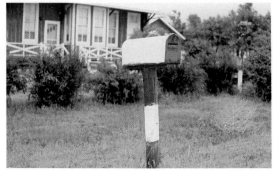

Bloom, Kansas

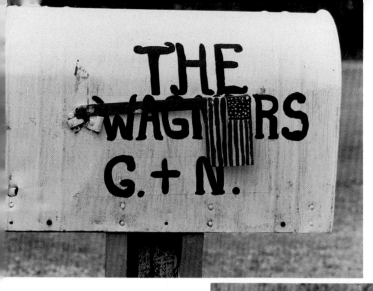

A Grand Ol' Flag!

Mailboxes across the country proudly display patriotic themes including Uncle Sam, stars and stripes of red, white and blue, and even Ol' Glory herself!

Leasburg, Missouri

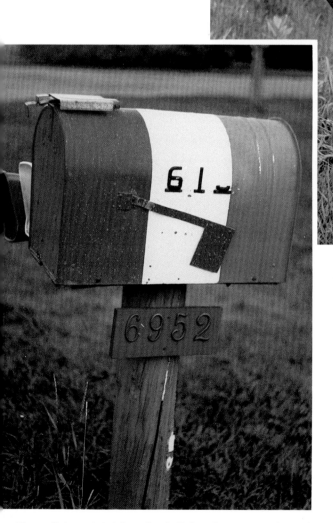

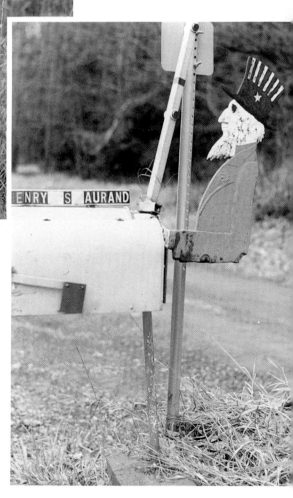

Above *(left to right):* Loveland, Colorado; Berry, Wisconsin; Shamokin Dam, Pennsylvania.

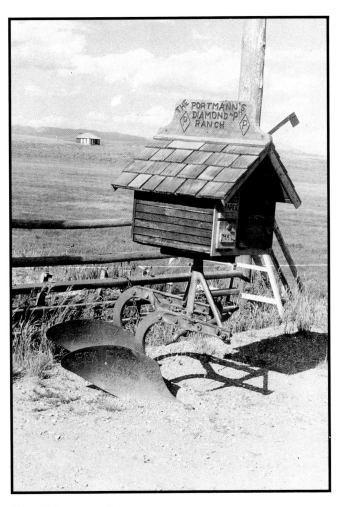

West Yellowstone, Montana

East of Crawford, Nebraska

Salina, Kansas

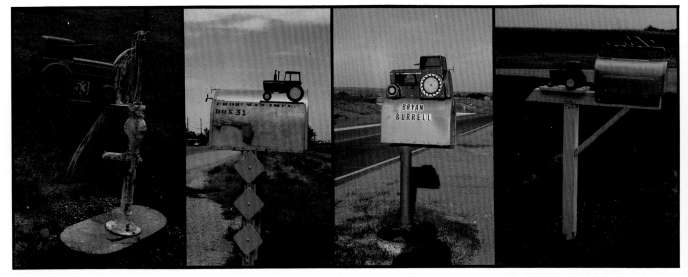

Jackson, Minnesota Pampa, Texas Fairview, Oklahoma Near Alphia, Minnesota

Plowing Time!

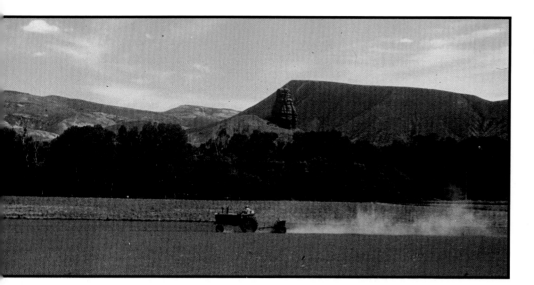

Plowing in Shell Creek Canyon, northwestern Wyoming

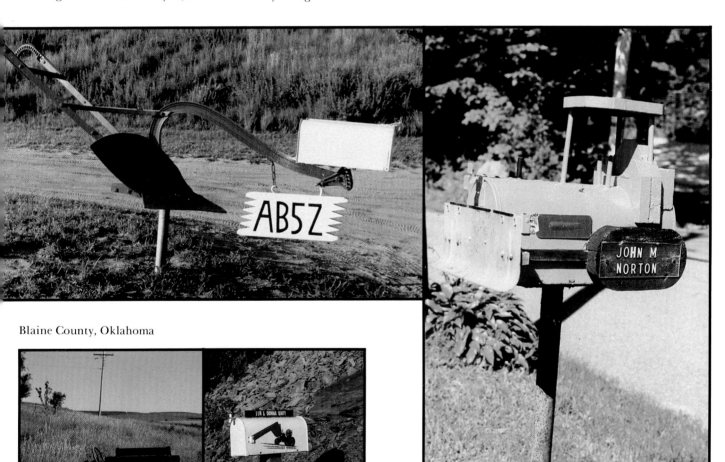

Blaine County, Oklahoma

Tyson, Vermont

Old farm equipment and model tractors make popular mailbox supports in R.F.D. Country!

Menominee, Nebraska

Box on milkcan, Penbryn, Pennsylvania

Cut-out of farmer plowing with oxen along Craw Fish Creek, near Trenton, Georgia.

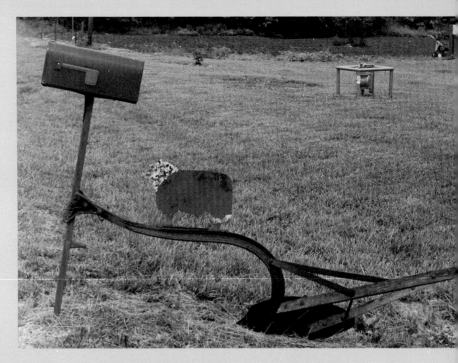

Cow on plow, west of Deerfield, Missouri

Troy, Pennsylvania

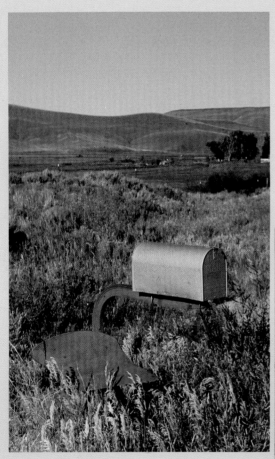

Gunnison, Colorado

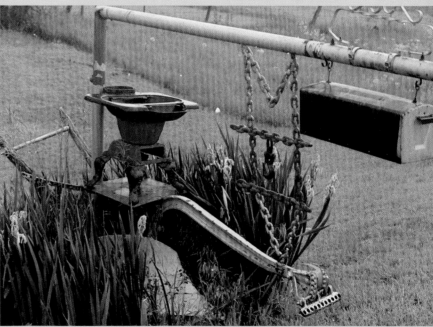

Plow with chainwork, west of Augusta, Kansas

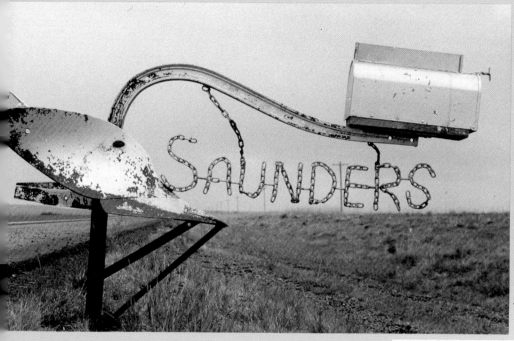

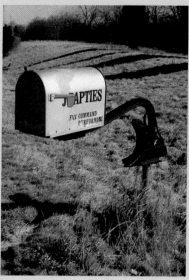

Wakefield, Rhode Island

Cascade, New Mexico

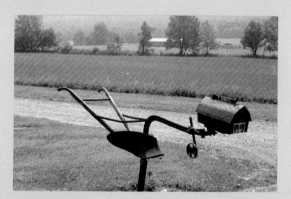

Eastville, Pennsylvania

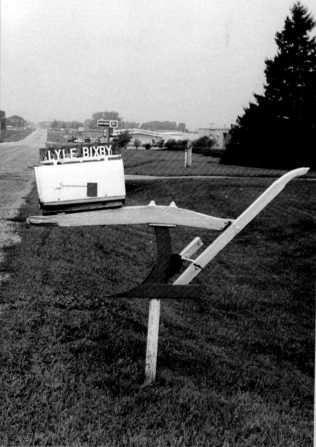

Fairmont, Minnesota

Hillside fields on Hopi Indian Reservation, Oraibi, Arizona

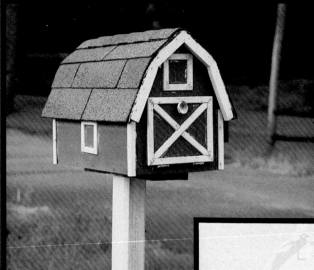

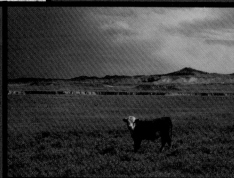

Farm scenes on boxes at
Loyalsockville, Pennsylvania

A miniature barn box, Cairo, Kansas.

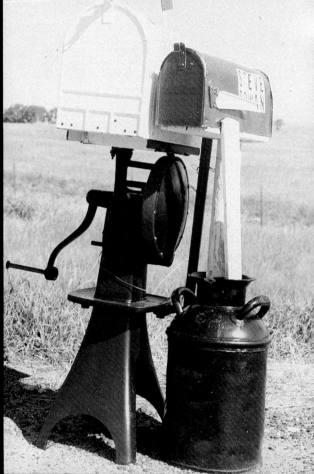

A cream separator and milkcan
provide bases for this handsome pair
of receptacles near Springview,
Nebraska.

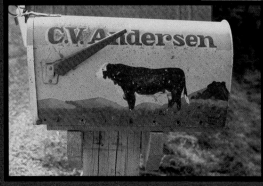

Right: A white-faced calf enjoys
springtime near Crawford, Nebraska.
Left: A mature bull depicted in
similar surroundings, Vale, Oregon.

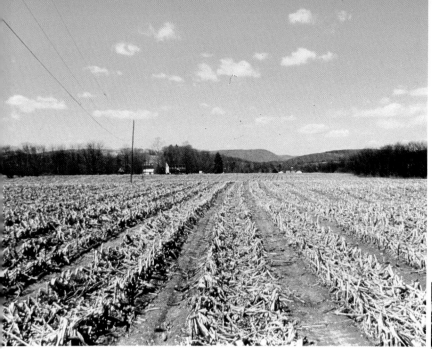

Harvested cornfield, Lycoming Creek valley, north-central Pennsylvania

Down on the Farm!

Many rural mailboxes reflect the activities of the working farm.

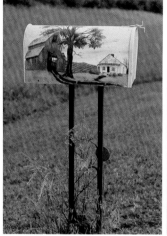

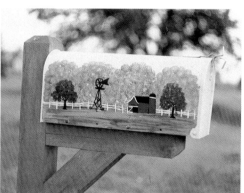

Hand-painted scenes decorate these Kansas mailboxes near Redfield *(left)* and Greensburg *(right)*.

Miniature silos support mailboxes on some Midwestern farms. **Below:** East of Rock Rapids, Iowa; **Right:** Shipshewana, Indiana.

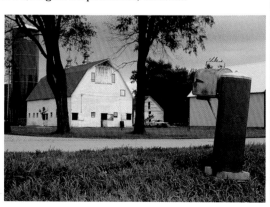

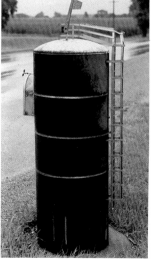

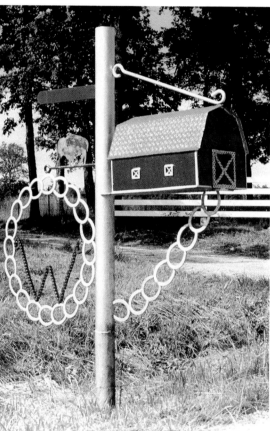

Elaborate box near Preston, Missouri. Note barn, buffalo, welded horseshoes and chainwork.

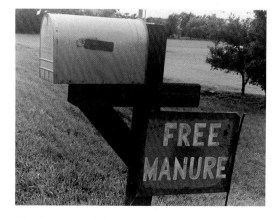

Sharing nature's bounty, Andover, Kansas

31

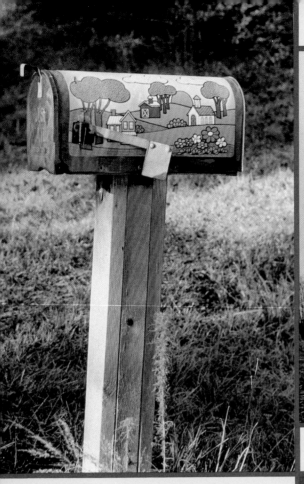

Basic City, Mississippi

Old elm and farmhouse near Jersey Shore, Pennsylvania

JACK E ALLEN

81 BLUEBIRD LANE

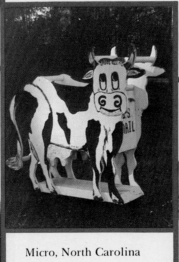

Micro, North Carolina

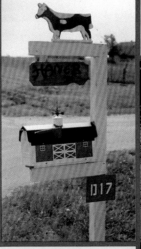

This dairy farm west of Nevada, Missouri, has an appropriate mailbox.

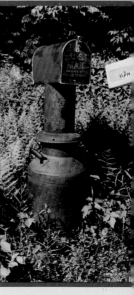

Marlboro, Vermont

Milkcan mailbox, Cody, Wyoming

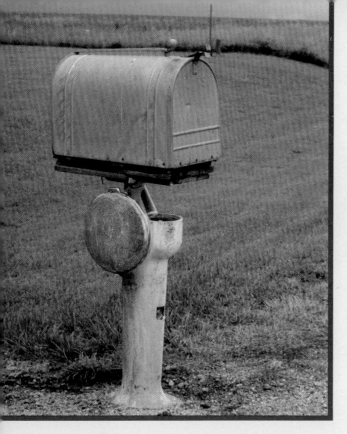

This box at Lattarpe, Kansas, reminds us that the cream separator is important equipment on a dairy farm.

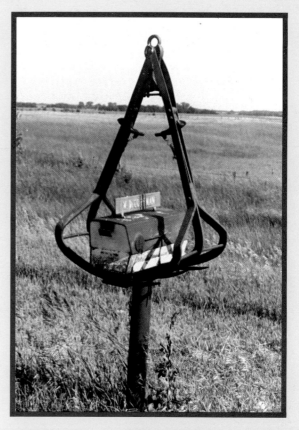

A hay lift and box near Sylvia, Kansas

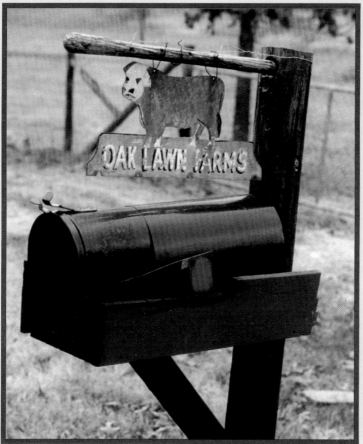

Chesterfield, New Hampshire

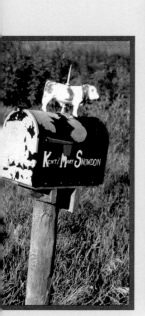

West of Niobrara, Nebraska

Oak Lawn Farms, DeKalb County, Alabama

West of North Platte, Nebraska

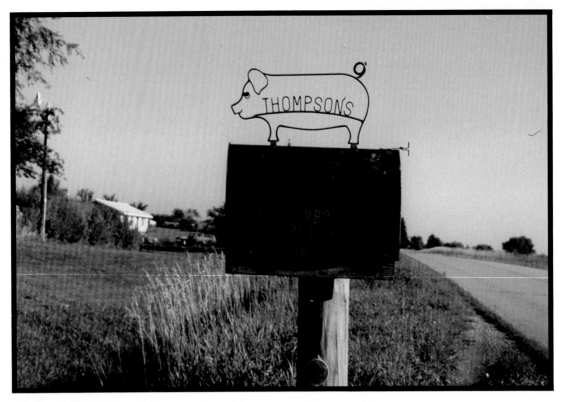

Pig farmers proudly proclaim their profession on boxes near Des Moines, Iowa.

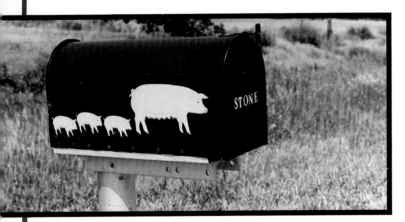

Larned, Kansas

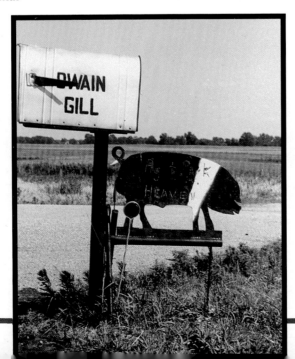

Wauseon, Ohio

34

Zenith, Kansas

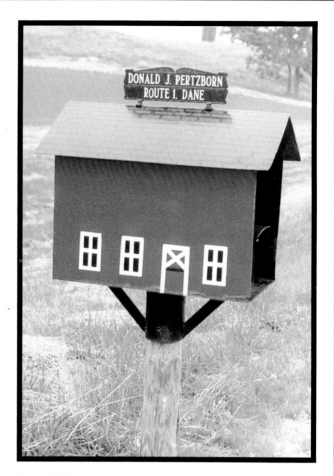

Dane, Wisconsin

A mailbox made from an old hay mower, Mt. Vernon, Missouri.

A tractor seat provides a perch close to this mailbox at Riceville, Tennessee.

Haystacks and fields along U.S. Route 20, near O'Neill, Nebraska.

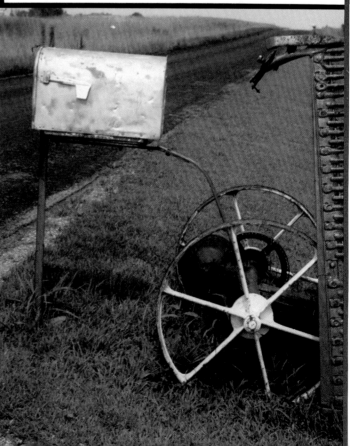

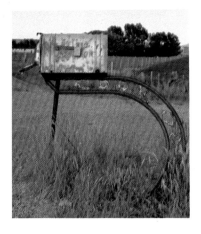

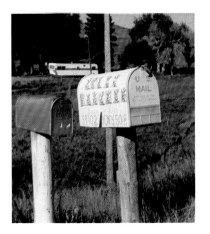

Decorative ironwork spells out the family name and adds a diamond, heart, club and spade to this Ririe, Idaho, box.

Doyleville, Colorado

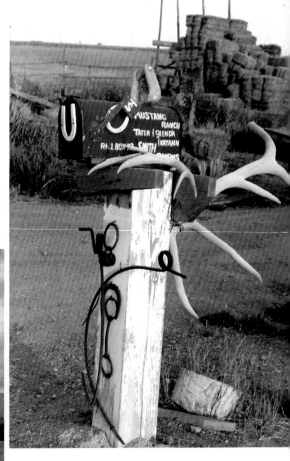

Above: Antlers and horse equipment festoon a ranch mailbox near Burns, Oregon.

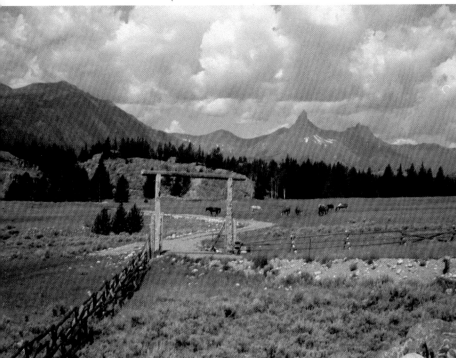

High-Plains ranch in the shadow of Pilot Mountain, Montana (*left*)

Above (*left to right*): West of Hay Springs, Nebraska; Lakeview, Oregon; Valentine, Nebraska

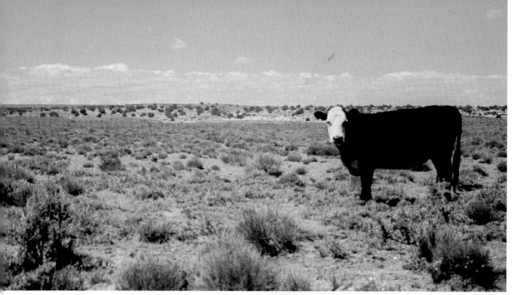

Home, Home on the Range!

Western ranchers are not to be outdone in creating distinctive mailboxes, many featuring the cattleman's brand.

The pose of this young beef *(above)* on the range near Woodruff, Arizona, seems to be caught on this box *(right)* west of Clayton, New Mexico.

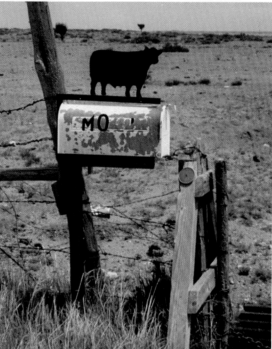

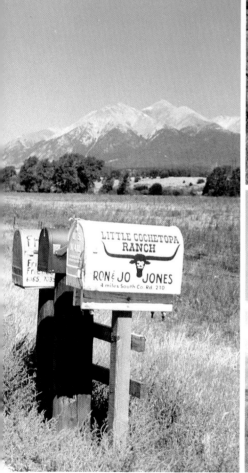

Tensleep, Wyoming

East of Monarch Pass, Colorado

Open range under Montana's big sky, near Great Falls

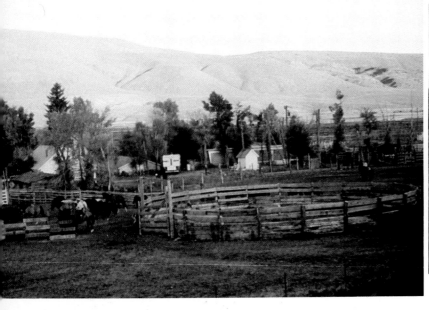

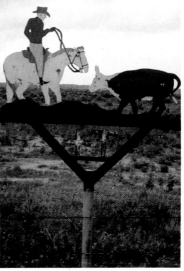

Corraling horses, Elko, Nevada

Metal cut-out and chainwork "D" mailbox entrance to Davies +T Ranch, Liberal, Kansas.

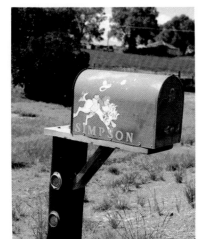

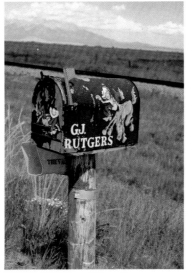

A pair of "buckin' bronco" boxes near Alamosa, Colorado

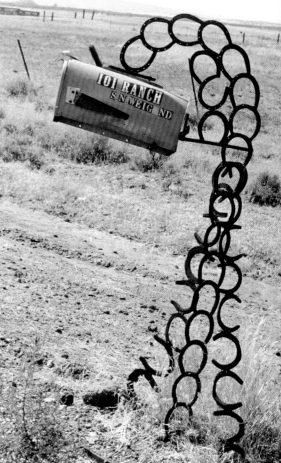

Welded horseshoes decorate western boxes. **Left to right:** Tubac, Arizona; near Mountain Home, Idaho; west of Adin, California.

How the West Was Won!

Above: Final resting place for the men of the defeated Seventh Cavalry, Custer Battlefield, Montana; *(left)* rings of stone outline ancient Indian teepee sites along the Shoshone River, Wyoming.

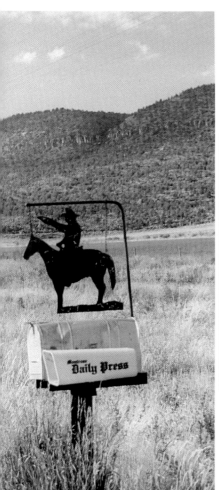

Mailboxes in the West evoke memories of cowboys and miners, railroads and round-ups!

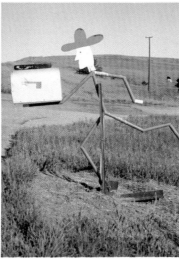

East of Monowi, Nebraska

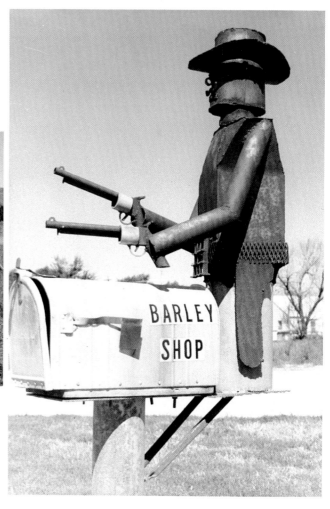

Range-rider south of Colona, Colorado

Quick-draw gunslinger protects a North Platte, Nebraska, mailbox.

39

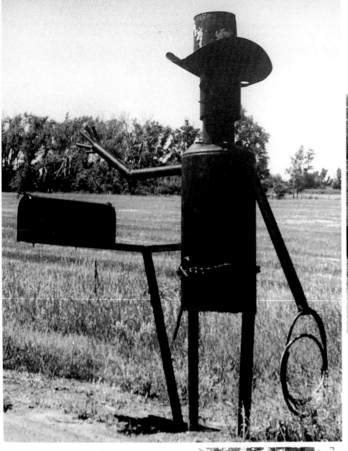

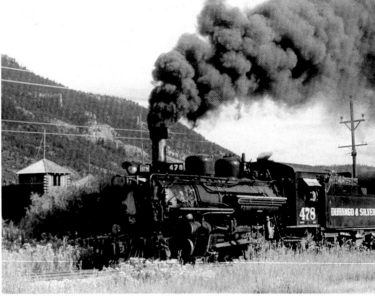

A smoke-belching locomotive makes a run between historic Durango and Silverton, Colorado.

Cowpunch, east of Larned, Kansas

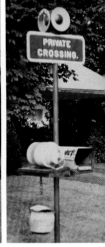

Remembering railroad days with a crossing signal, Williamsport, Pennsylvania *(right)*; a caboose box *(center)* near Banner, Wyoming; and telegraph pole with insulators, Dover, Wisconsin *(left)*.

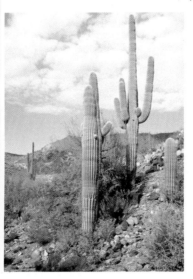

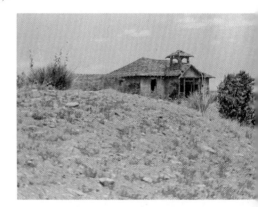

Abandoned schoolhouse near Cimarron, New Mexico

A Cottonwood, Arizona, mailbox depicts saguaro cacti like those seen in Arizona's Superstition Mountains.

Ghostly reminders of Western mining days. **Right:** Victor, Colorado.

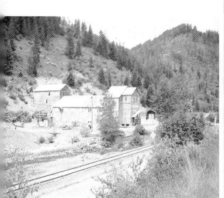

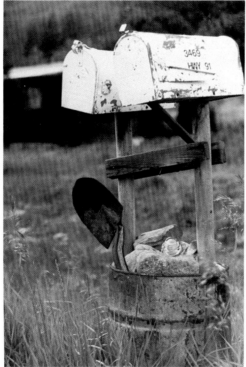

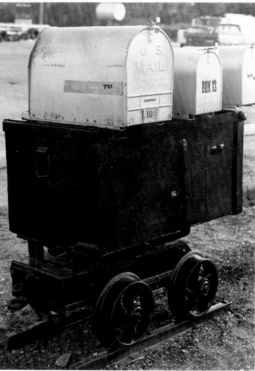

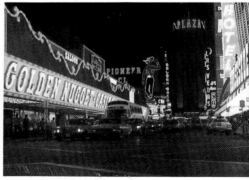

An old flour can still serves as a mailbox in the Verde Valley, Arizona.

Middle: *(left)* Golconda Mine, Mullen, Idaho; *(center)* mailboxes and miner's cabin, north of Leadville, Colorado; *(right)* mailboxes perched on an old ore cart, Buffalo, Wyoming. **Bottom:** *(left)* South Pass City, Wyoming; *(right)* a modern way to "strike-it-rich", Las Vegas, Nevada.

Enterprise, Mississippi

A black stallion supports the U.S. Mail in Slidell, Louisiana.

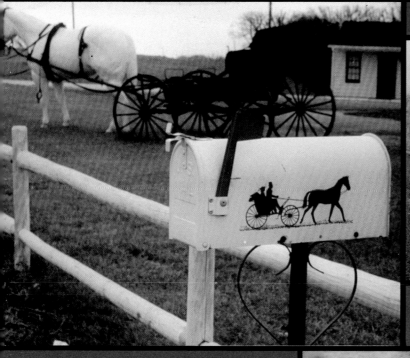

Elgin, Illinois

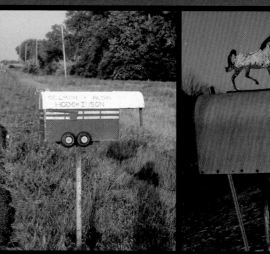

A horse-trailer mailbox in Cadro, Kansas *(left)*; and a prancing horse tops a box in Ashland, New York *(right)*.

Hagerstown, Maryland

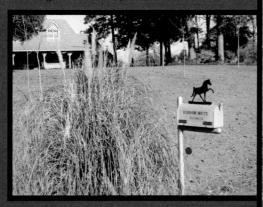

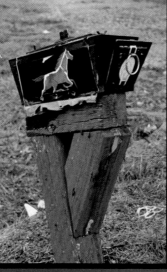

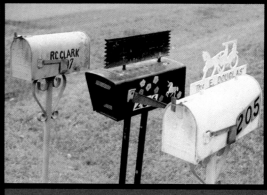

Proud horses and a unicorn sport on mailboxes in Laurel, Mississippi *(above)*, and Athens, Tennessee *(right, far right)*.

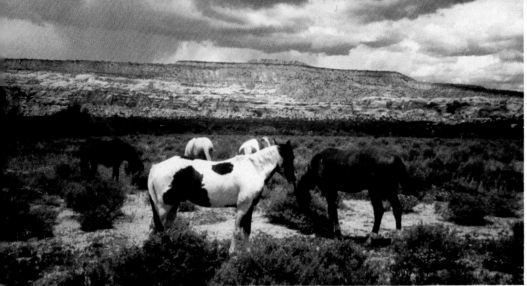

Pony Express!

Horses are a favorite subject for mailboxes in every part of R.F.D. Country!

Acoma Pueblo Indian Reservation, New Mexico

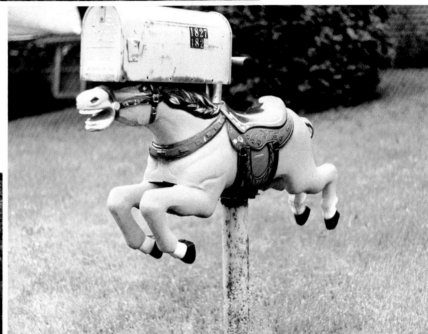

Williamsport, Pennsylvania

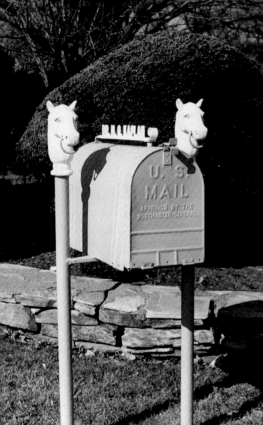

We found this horse-powered box in Wakefield, Rhode Island.

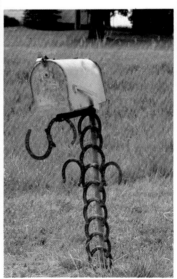

Original Pony Express way-station, Gothenburg, Nebraska. Young horsemen sped letters from St. Joseph, Missouri, to Sacramento, California, in just 10 days. But the transcontinental telegraph replaced the service in 1861, only 18 months after it began.

A trail of horseshoes led to this mailbox *(left)* near Fort Scott, Kansas.

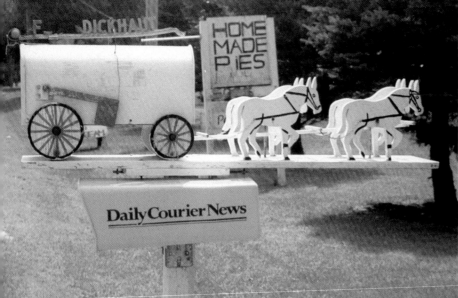

West of Elgin, Illinois

Opposite page: Cody, Wyoming

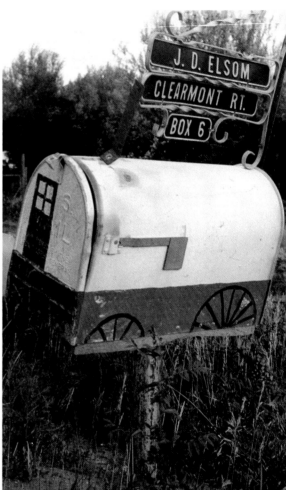

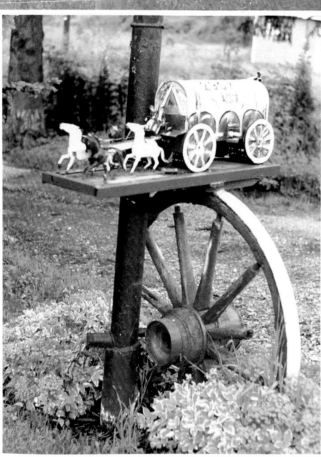

Old Lycoming Township, Pennsylvania

Buffalo, Wyoming

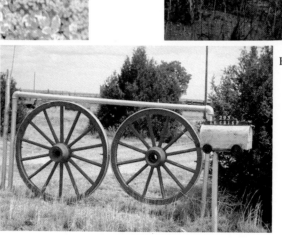

West of Clayton, New Mexico

44

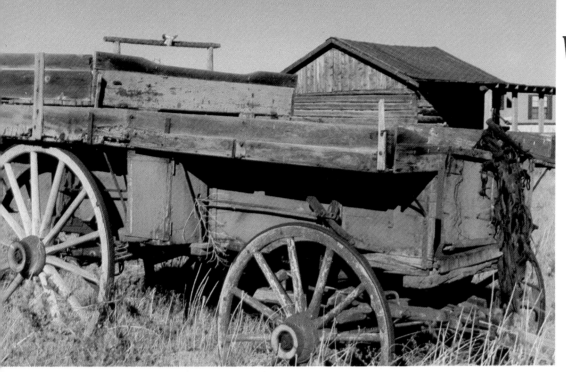

Conestoga wagons carried emigrants and goods across the Great Plains in the nineteenth century. Today, mailboxes evoke memories of Oregon Trail days, when the wagon-master urged the teams forward with a resounding "Wagons Ho!"

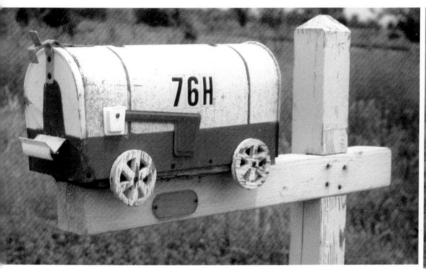

Afton, Oklahoma

Dade County, Georgia

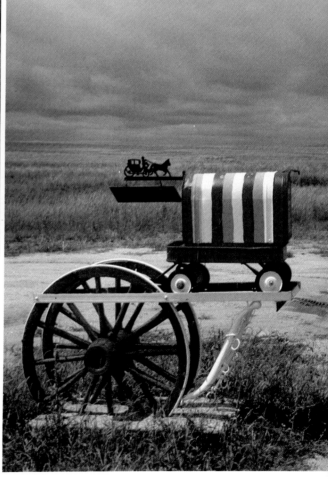

East of Matheson, Elbert County, Colorado

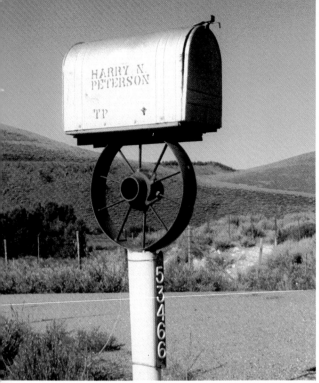

Parlin, Colorado

Crawford, Nebraska

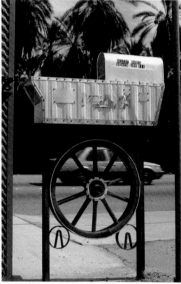

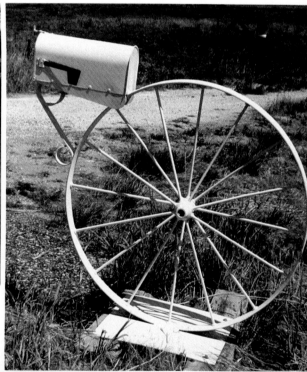

Bloom, Kansas

Indio, California

Mailbox and ranchgate,
Merriman, Nebraska

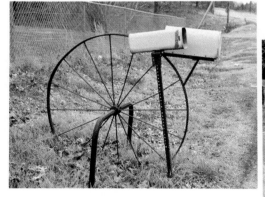

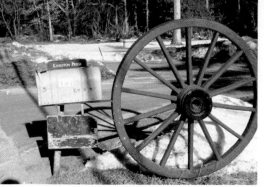

Head Springs, Alabama

46

West Kingston, Rhode
Island

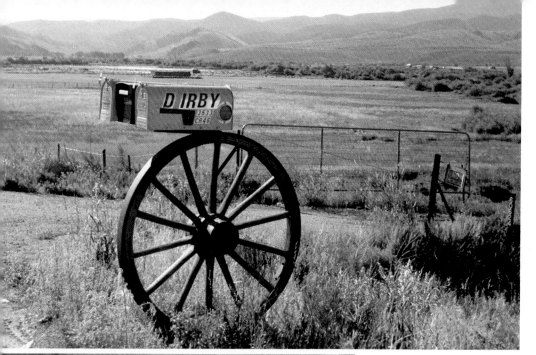

Big Wheels!

Big wheels—and little wheels, too—may be recycled as mailbox supports.

Doyleville, Colorado

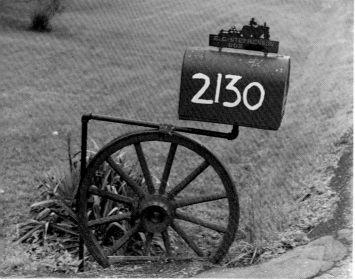

Big Bone Lick, Kentucky

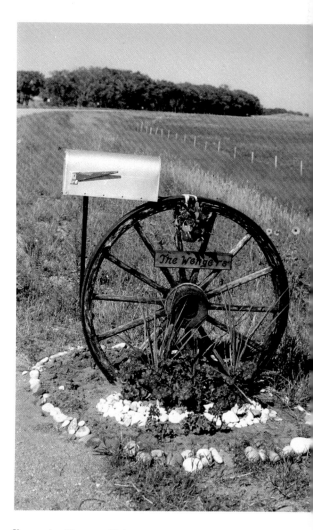

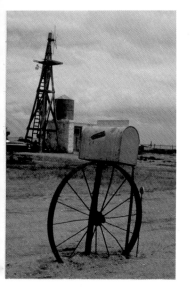

West of Four Corners, Oklahoma

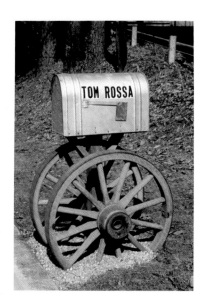

A two-wheeler, Branchville, New Jersey

Keyapaha County, Nebraska

47

Wheel of Fortune!

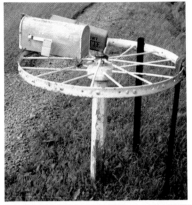

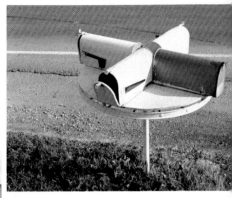

Clockwise *(from upper left):* Nisbet, Pennsylvania; Mt. Sidney, Virginia; Hay Springs, Nebraska; Poncha Springs, Colorado

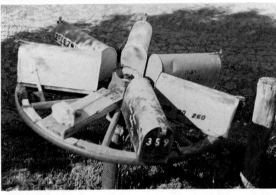

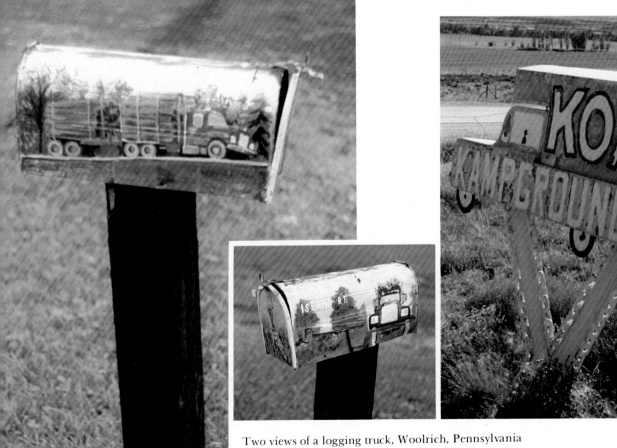

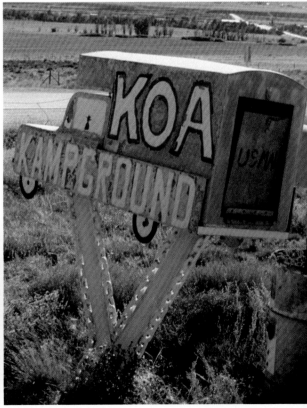

Two views of a logging truck, Woolrich, Pennsylvania

Buena Vista, Colorado

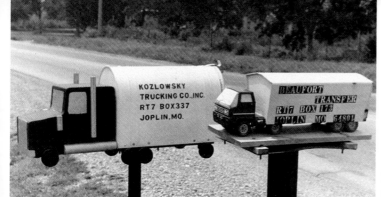

Joplin, Missouri

Keep on Truckin'!

Huge trucks with roaring engines haul heavy payloads across the nation. Along the roadside, tiny replicas of these "Kings of the Highway" await the morning mail delivery.

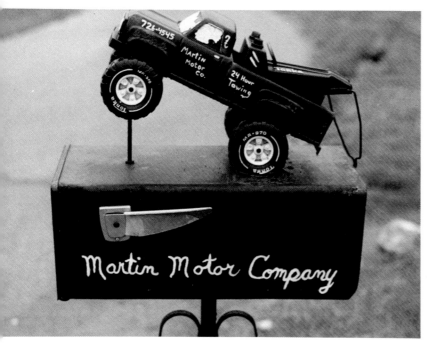

Mill Hall, Pennsylvania

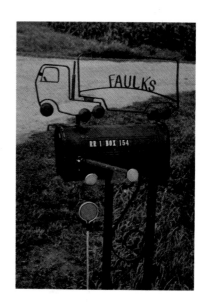

Welcome, Minnesota

Leesburg, Florida

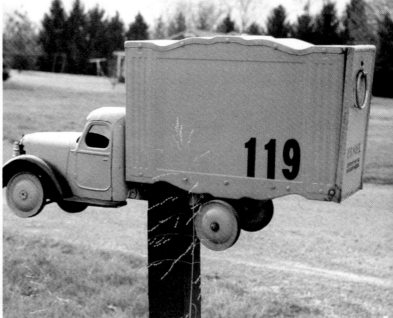

Marlowe, West Virginia

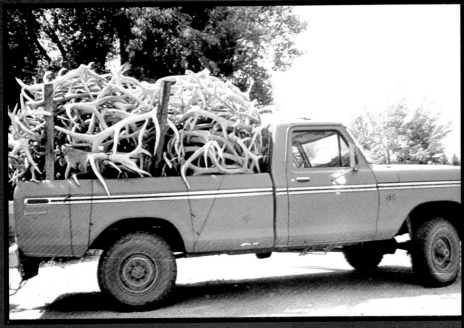

People and animals! While dogs, cattle and horses are among the most popular mailbox livestock, nearly every other kind of critter shows up somewhere in R.F.D. Country!

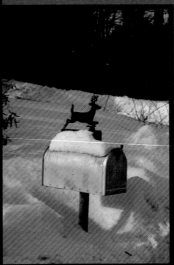

Deer are plentiful in R.F.D. Country! **Right:** Putnam, Connecticut. **Above:** Elk Antlers shed in winter are collected in places like Grass Valley, Wyoming.

Reindeer box, Fort Payne, Alabama

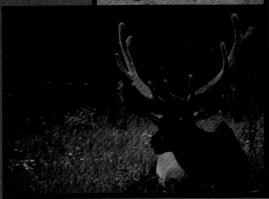

Bull elk in velvet, northwestern Wyoming.

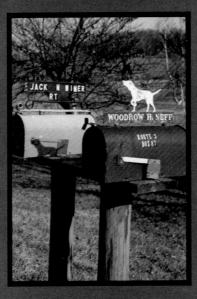

Snoopy on his doghouse roof, New Market, Virginia

South of Linville, Virginia

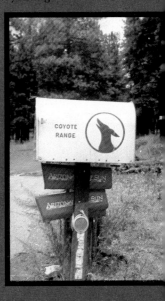

Flagstaff, Arizona

50

Mailbox Menagerie!

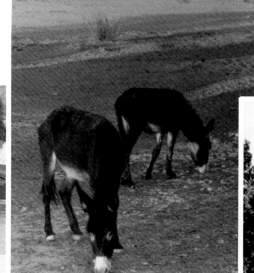

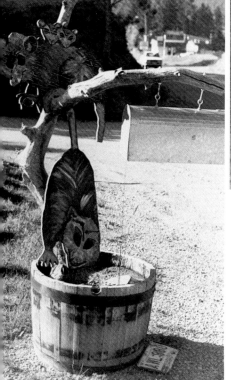

Burros at sunset, east of Yuma, Arizona

Playing 'possum, Custer, South Dakota

Fairview, Oklahoma

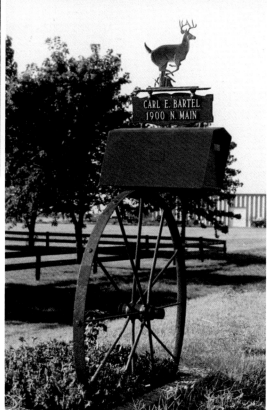

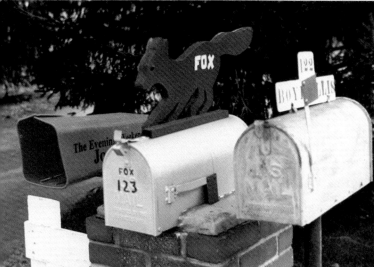

Marlowe, West Virginia

Woolrich, Pennsylvania

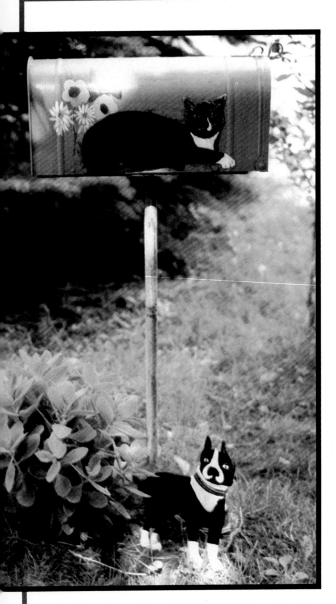

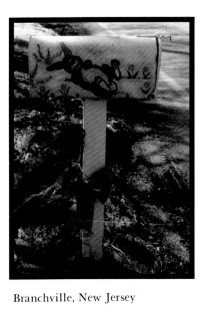

Imogene, Minnesota

Branchville, New Jersey

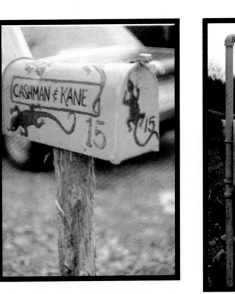

A handsome kitty, Williamsport, Pennsylvania

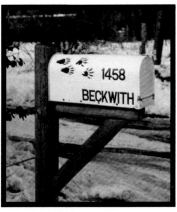

(Left) Making tracks, Dighton, Massachusetts; *(right)* Lower Matacumbe Key, Florida

Lizards crawl on this box in Wakefield, Rhode Island

Scottie box, Trenton, Georgia

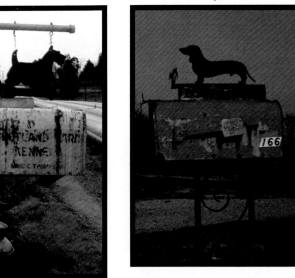

Dachshund, Lacey Spring, Virginia

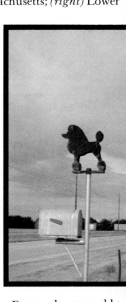

French poodle, Andover, Kansas

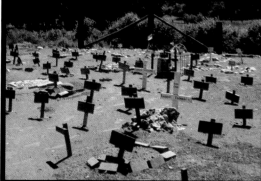

People celebrate their pets on mailboxes and commemorate them in special cemeteries, like this one in Salida, Colorado.

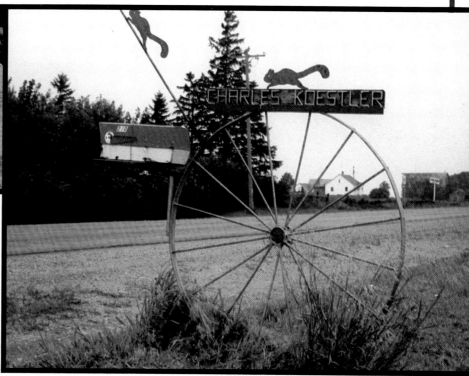

Life-like squirrels scurry over this Imogene, Minnesota, mailbox.

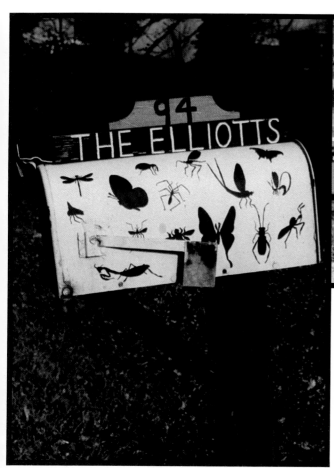

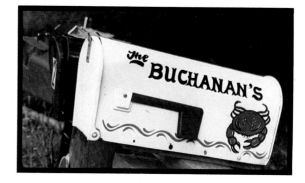

Even insects appear on mailboxes. **Above:** near Harrisonburg, Virginia *(left)*; a most unusual bug, Lovell, Wyoming *(center)*; Liverpool, Pennsylvania *(right)*.

Narragansett, Rhode Island

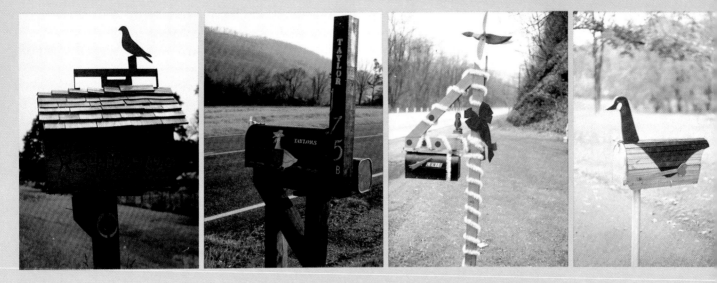

Above *(left to right):* Seneca, Missouri; north of Collinsville, Alabama; Christmas duck, Liverpool, Pennsylvania; Canada goose, Seekonk, Massachusetts.

Flying ducks, Staunton, Virginia

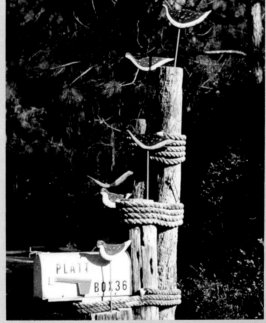

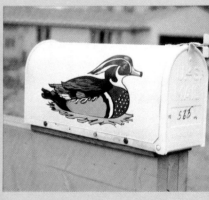

Coastal Rhode Island

Shore birds and pilings, *(left)* St. George Sound, Florida

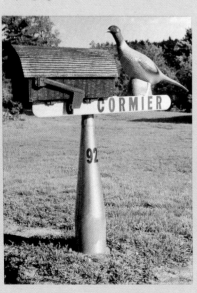

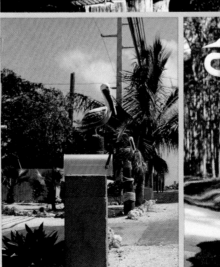

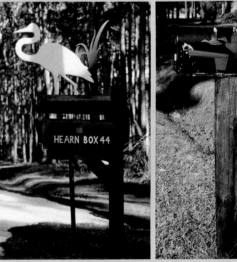

Above *(left to right):* Ashburnham, Massachusetts; pelican, Islamadora, Florida; heron, St. James, Florida; St. Tammany Parish, Louisiana

For the Birds!

A flock of mailboxes representing birds of many feathers!

Devil's Elbow, Oregon

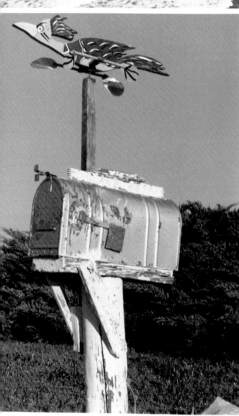

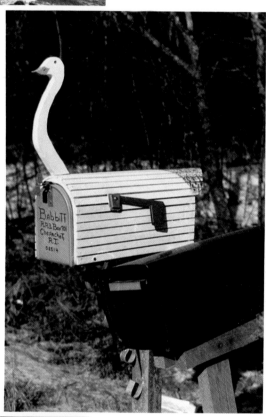

Roadrunner, east of Vici, Oklahoma

White swan, Chepachet, Rhode Island

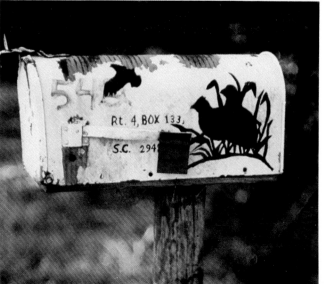

Quail, south of Walterboro, South Carolina

55

Rhode Island Reds!

Rhode Islanders are proud of the chicken first bred in their state, the Rhode Island Red. Excellent layers, the hens produce brown-shelled eggs favored by many cooks. The breed is celebrated on several mailboxes, but no one outdoes a Wakefield, Rhode Island, lady. Antoinetta Goodwin dresses her chickens in handmade costumes for every occasion. Here is just a sample.

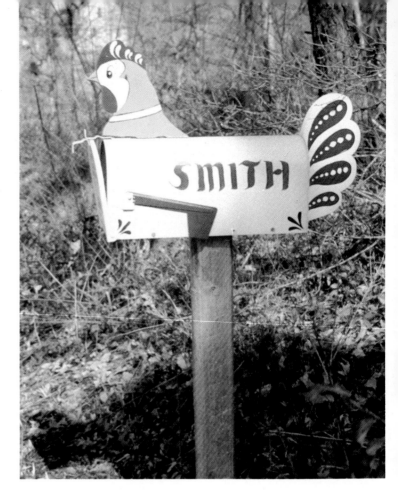

Charlestown, Rhode Island

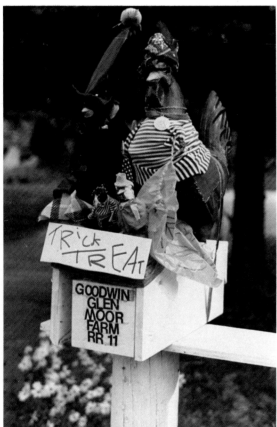

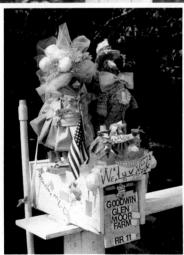

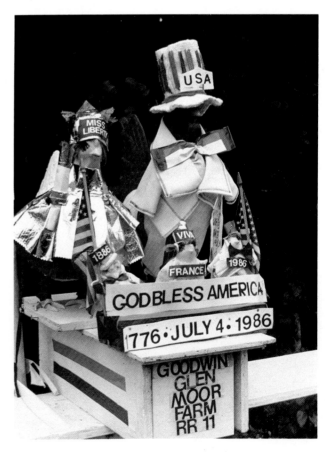

Above: Halloween; *(lower)* Mother's Day

Independence Day

56

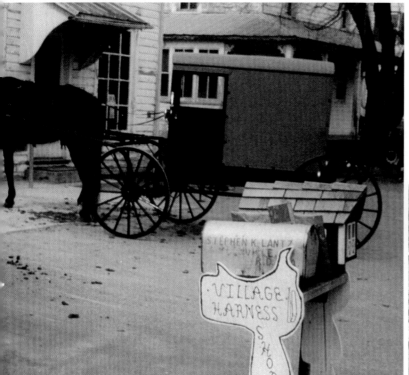

Intercourse, Pennsylvania

Colorful folk art brightens the otherwise conservative lifestyle of Pennsylvania German sects like the Mennonites and Amish.

Plain *and Fancy!*

Two views of a model woodstove mailbox with painted designs, Julian, Pennsylvania.

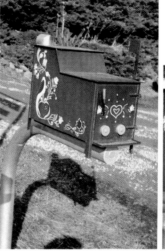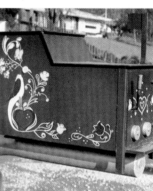

Stylized "distelfink" (finch) and flowers on a box topped by a miniature barn and silo, Beech Creek, Pennsylvania.

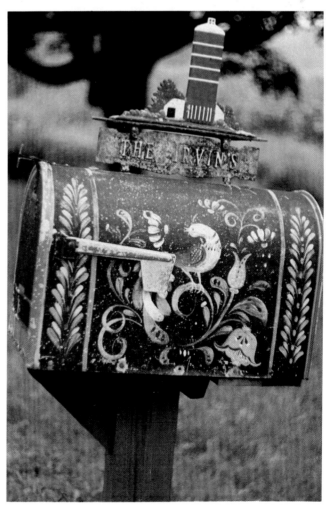

Pennsylvania Dutch "hex" sign, Loyalsockville, Pennsylvania

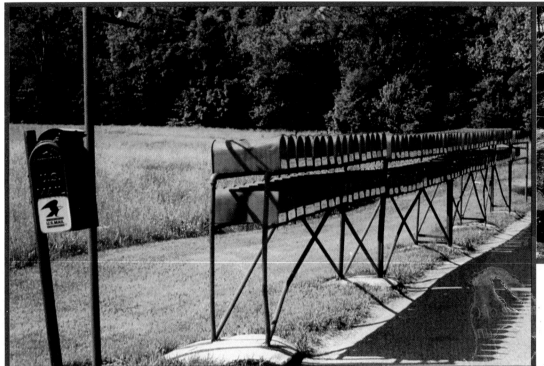

Delaware Valley

Double-decker row of 124 boxes, west of Brattleboro, Vermont.

Mailboxes and adobe wall, Albuquerque, New Mexico

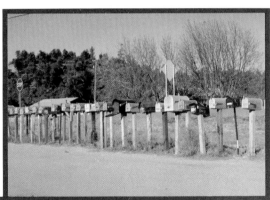

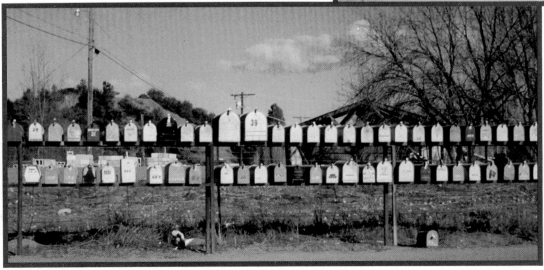

Above and right: Two groups of mailboxes, Star Valley, Arizona

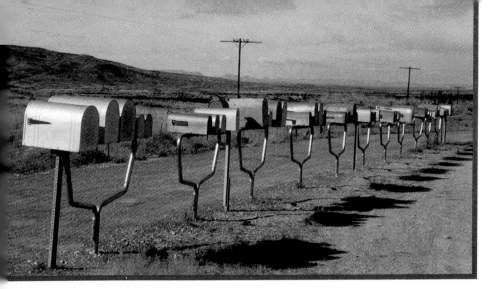

Highway 118, southwest Texas

Friends and Neighbors!

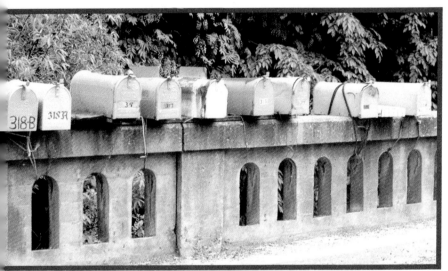

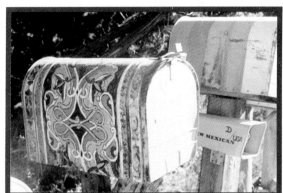

American and Spanish themes coexist along the Old Pecos Trail, New Mexico.

Boxes on a bridge, Tomb's Run, Pennsylvania

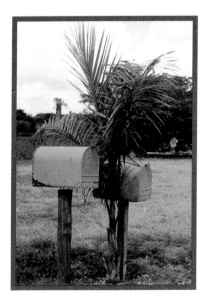

Dade Corners, Florida

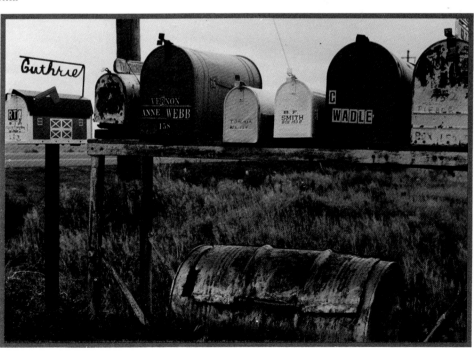

West of Guyman, Oklahoma

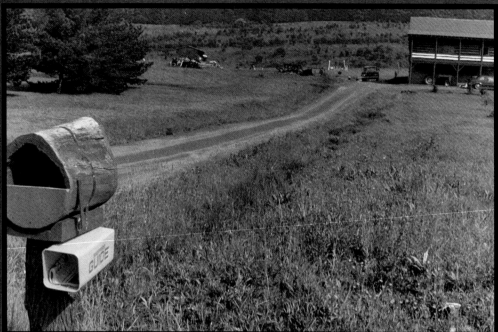

Mailbox self-portrait, Valley Head, Alabama

Log cabin with log mailbox, Bald Eagle, Pennsylvania

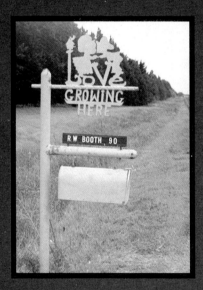

El Dorado, Kansas

Alba, Pennsylvania

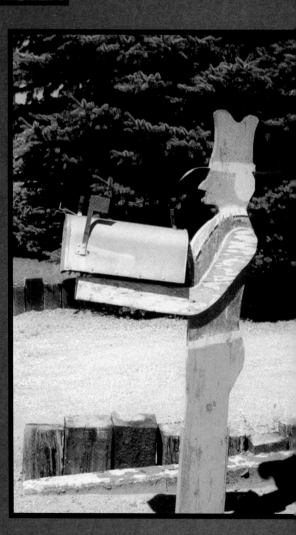

Uncle Sam's country cousin, Salida, Colorado

Mount Sidney, Virginia

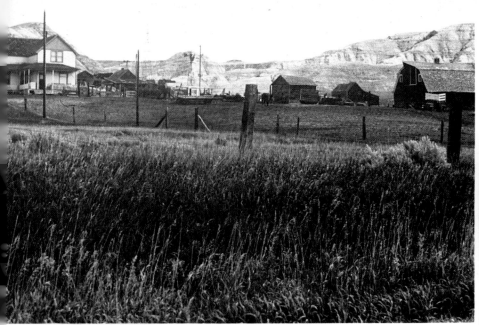

Country Cousins!

North Dakota ranch

Somehow, life seems quieter—and a little simpler—in R.F.D. Country!

Nesting goose, Collinsville, Alabama

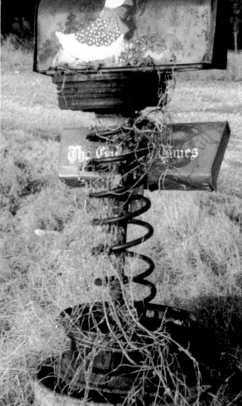

Greene, Rhode Island

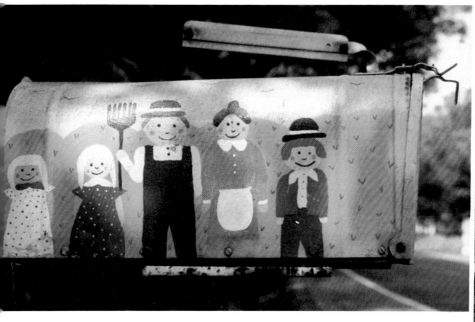

Donation, Pennsylvania

Yemassee, South Carolina

Stumped!

The problem of mounting a mailbox has driven some postal patrons up a tree!

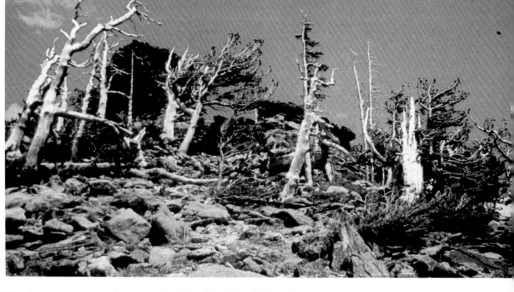

Weathered trees near the summit of the Rockies, Colorado

Evergreen box, Santa Fe, New Mexico

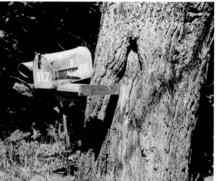

"Treed" in Vernon, Vermont

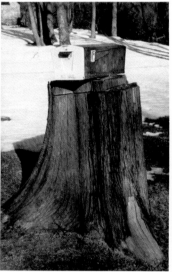

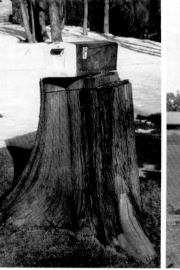

Rumford, Rhode Island

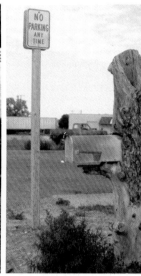

Idaho Falls, Idaho

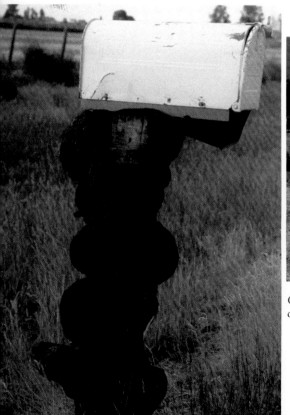

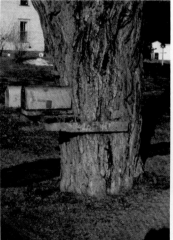

Out on a limb, south-central Colorado

These boxes (**above:** *right, far right*) put down roots close together in Roaring Branch, Pennsylvania.

This mailbox seems to be on top of a knotty situation in Idaho Falls, Idaho.

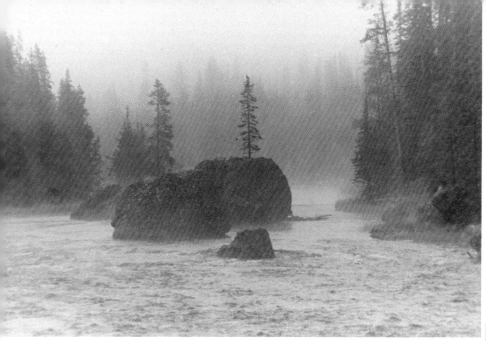

Madison River on a foggy morning, Yellowstone National Park

Lancaster County, Pennsylvania

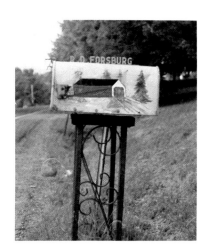

Nisbet, Pennsylvania

Over the River!

Old-fashioned covered bridges are remembered on mailboxes in the Northeast.

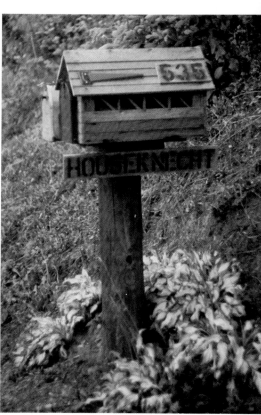

Muncy Valley, Pennsylvania

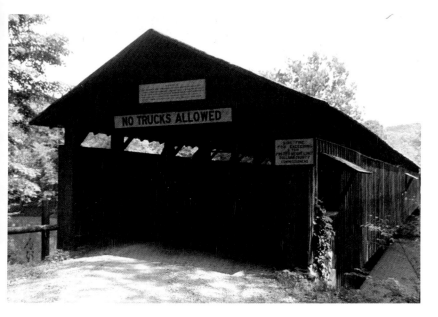

Covered bridge, circa 1850, Hillsgrove, Pennsylvania

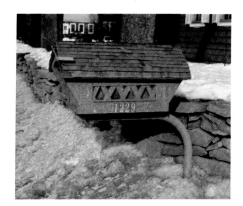

Dighton, Massachusetts

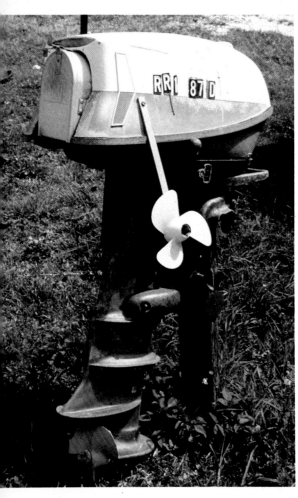

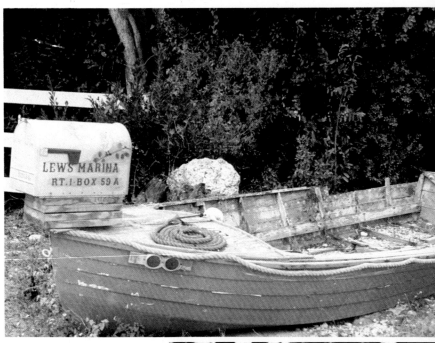

Above: Outboard motor mailbox, Key Largo, Florida; **below:** lighthouse scene, southeastern Pennsylvania *(left);* Perryville, Rhode Island *(right).*

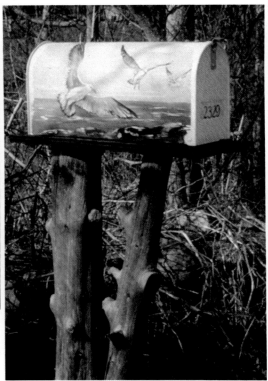

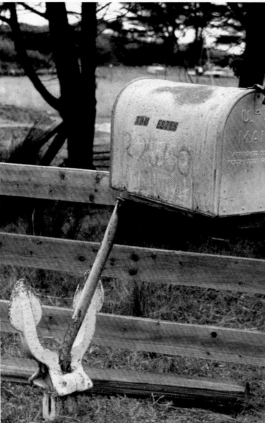

Above: Beached on Upper Matecumbe Key, Florida *(upper);* Mendocino County, California *(lower).*

Anchors Aweigh!

Nautical themes are popular from coast to coast!

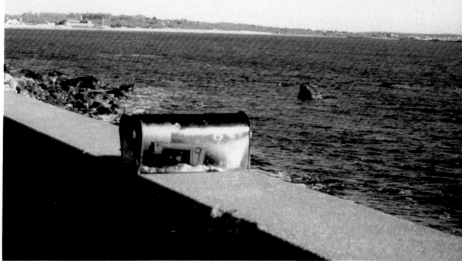

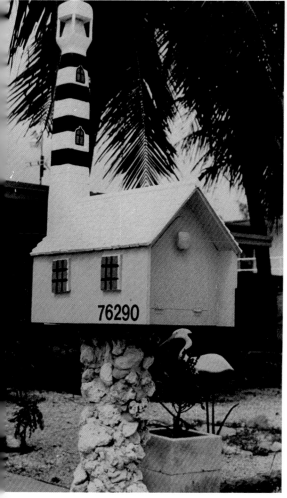

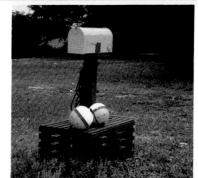

Mailbox on seawall, Narragansett Pier, Rhode Island

Lower Matecumbe Key, Florida— where the buoys are!

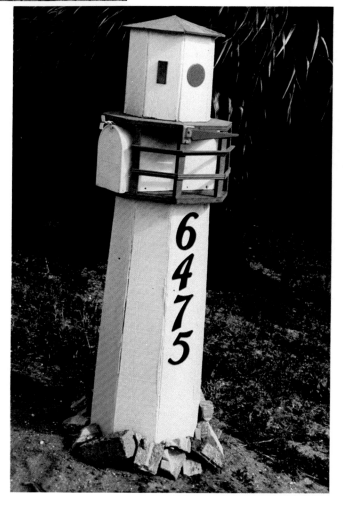

Lighthouse box, Islamadora, Florida

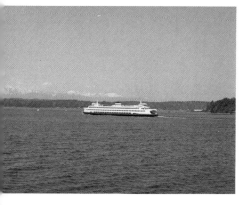

Washington State Ferry carries mail and passengers between Seattle and Bremerton.

South of Cocoa, Florida

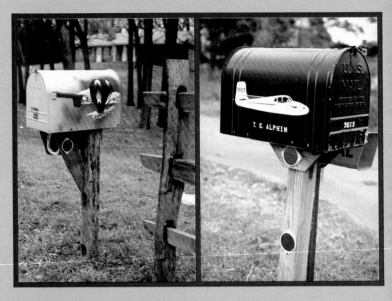

A pair of painted boxes, State Line, Maryland

This box sports a weathervane, Bosstown, Wisconsin.

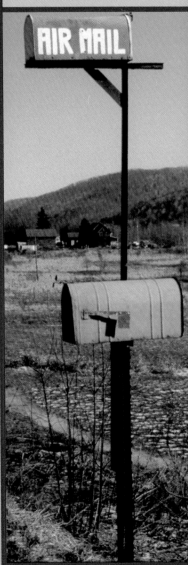

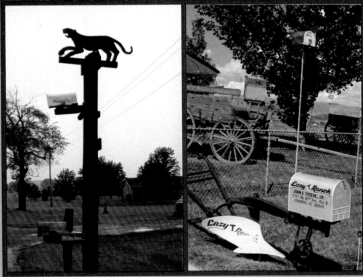

Left: North of Canton Lake, Major County, Oklahoma *(top);* a panther protects this airmail box near Brushy Prairie, Indiana; Longmont, Colorado *(bottom).*

Snedeckerville, Pennsylvania

Airmail!

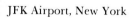

JFK Airport, New York

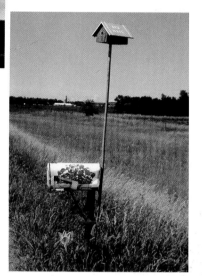

Birdhouse box, Yankton, South Dakota

Platte River valley, eastern Nebraska

Alpine, Texas

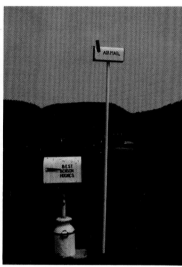

North-central Pennsylvania

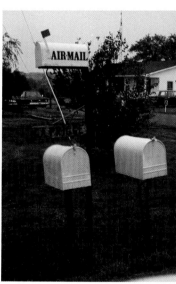

Union, Kentucky

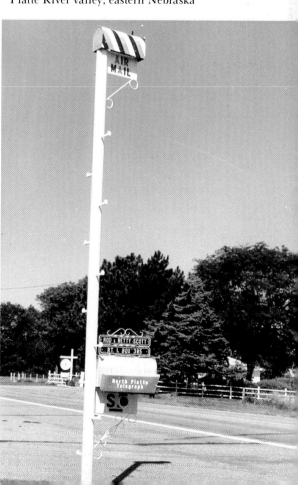

Wildwood, Florida

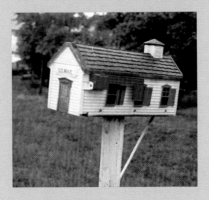

Schoolhouse, southwestern Kansas, is a commercial box.

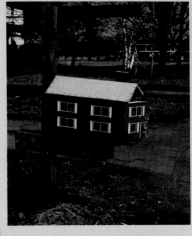

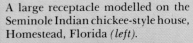

Big Flats, New York

A large receptacle modelled on the Seminole Indian chickee-style house, Homestead, Florida *(left)*.

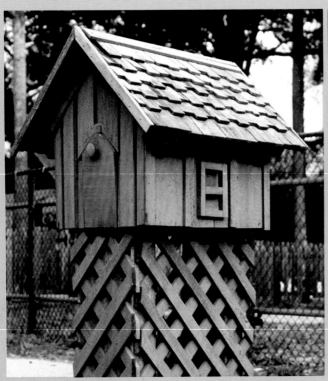

Jacksonville, Florida

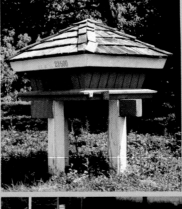

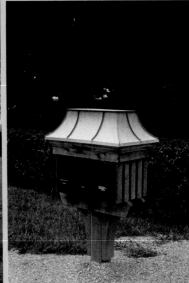

Williamsport, Pennsylvania

Independence, Missouri

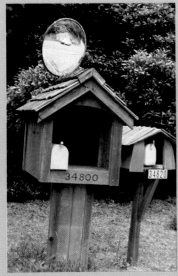

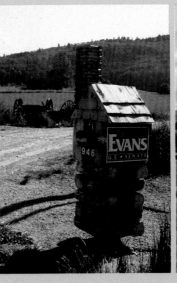

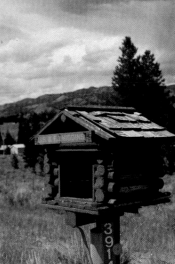

A mirror on the larger box reflects a dangerous curve, Anchor Bay, California.

Florence, Kentucky

Log cabin mailboxes flavor the Rocky Mountain West. Victor, Idaho.

Sunlight Basin, Wyoming

When a House Is Not a Home!

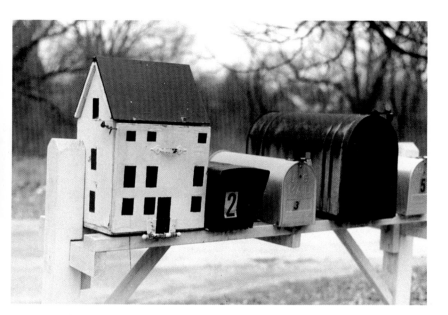

"Home delivery" takes on new meaning when the letter carrier brings mail to these little houses!

Peace Dale, Rhode Island

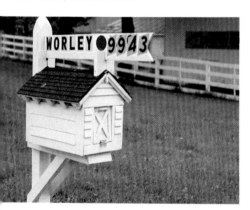

Another box in Kentucky's "bluegrass" horse-raising country

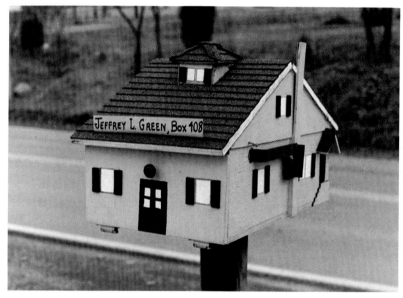

Berkeley, West Virginia

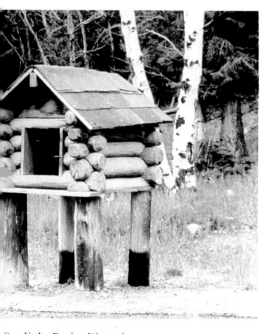

Sunlight Basin, Wyoming

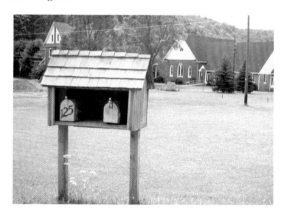

Warrensville, Pennsylvania

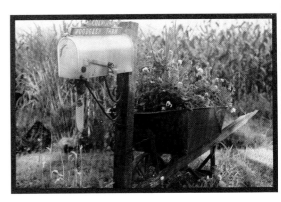

A planter in Lycoming County, Pennsylvania

Tulips near a mailbox in southern Rhode Island

A variety of pretty flowers—from plastic to petunias—brighten the mailboxes of R.F.D. Country!

Burns, Oregon

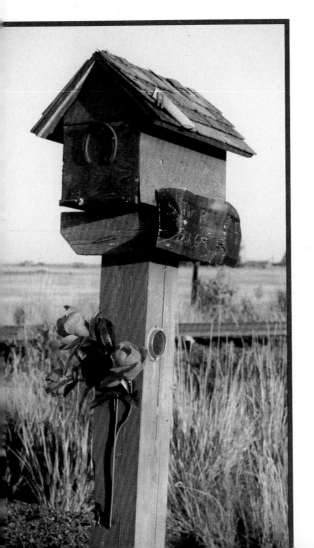

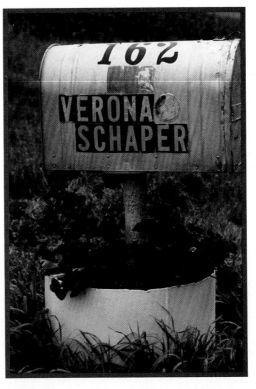

Northeast of Frost, Minnesota

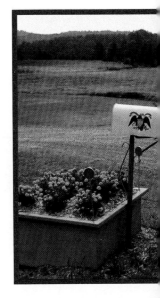

Loyalsockville, Pennsylvani

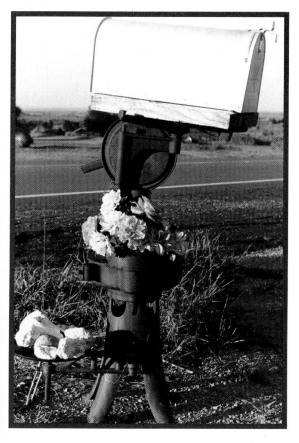

Naper, Nebraska

Postal Planters!

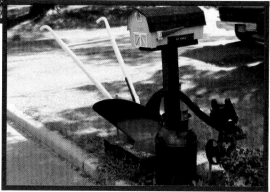

Corning, New York

An old cream separator holds a bouquet of flowers and white stones, east of Vici, Oklahoma.

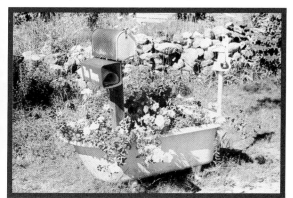

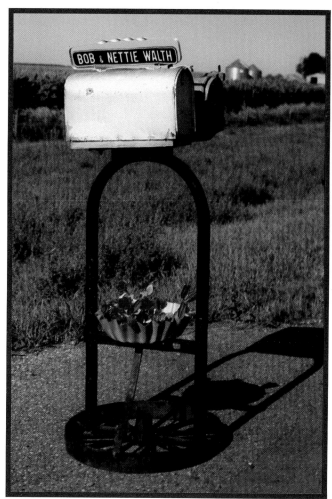

Brimfield, Massachusetts

Fairfax, South Dakota

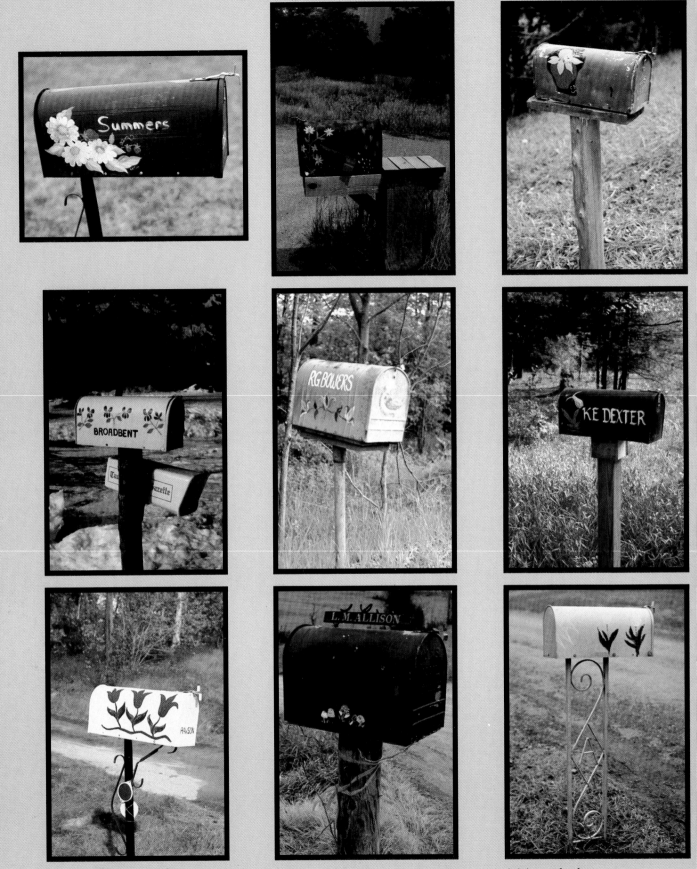

Above *(clockwise, from upper left):* A garden of flowers—Loudon, Tennessee; daisies and others Hermosa, Colorado; special strawberry, Rising Fawn, Georgia; Foster, Rhode Island; yellow tulips, Athens, Tennessee; colorful mushrooms, south of Trenton, Georgia; red tulips, near Summit, Rhode Island; violets in snow, Taunton, Massachusetts. *Center:* Pennsylvania Dutch bird and flowers, Salladasburg, Pennsylvania.

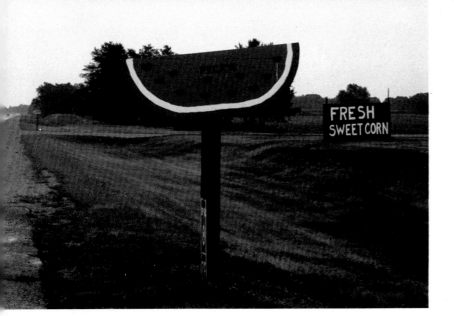

Garden Grown!

Lone Rock, Wisconsin

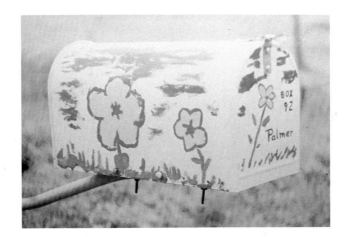

Chepachet, Rhode Island

Hot red chili peppers dry from a New Mexico box.

Grant, Florida

The pineapple is a sign of welcome in New England.

73

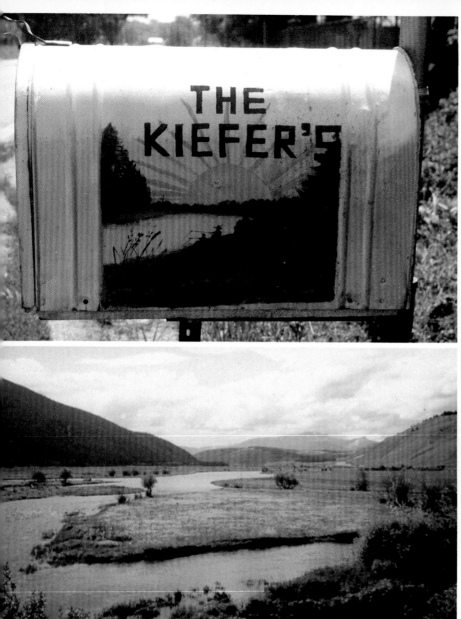

Shoshone River, Cody, Wyoming

The view of Big Hole Valley in southwest Montana *(above)* reminded us of a mailbox in Coral, Illinois *(top)*.

Lolo River, northern Idaho

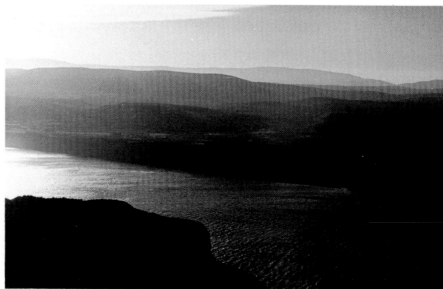

Columbia River, Vantage, Washington

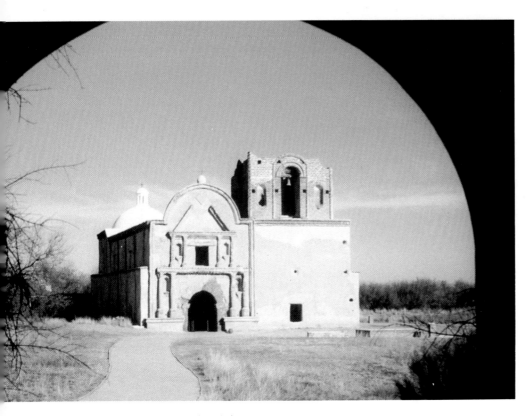

Tumacacori Mission, north of Nogales, Arizona

Many times the scenery on the other side of the road drew our attention from the mailboxes. The beauty and variety of R.F.D. Country extends from coast to coast, across mountains, rivers and deserts!

East of Burns, Oregon

Big Bend of the Rio Grande, Texas

Above: *(right)* Vultures in cypress trees at dawn, Fisheating Creek, Florida; *(left)* mailbox surrounded by blooming bougainvillia, Windley Key, Florida

Climax, Colorado

North of San Luis Obispo, California

Narragansett Bay, Rhode Island

Cloud Peak, Big Horn Mountains, Wyoming

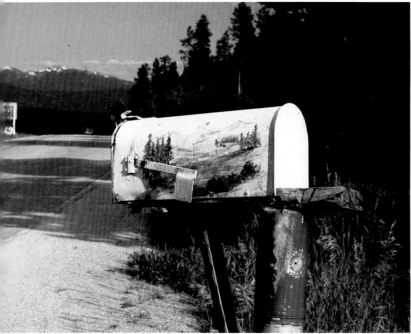

Indian Peaks, Blackhawk, Colorado

Mailbox dwarfed by ponderosa pines, Mt. Humphreys, Flagstaff, Arizona

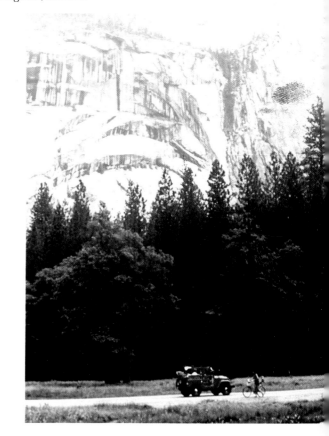

Yosemite, California

Mt. Washington, New Hampshire

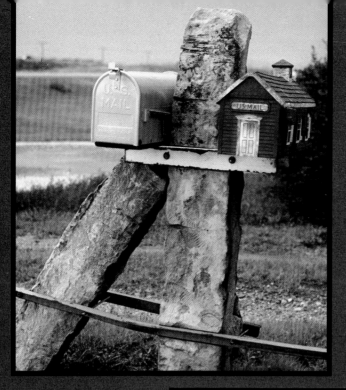

Two post rocks supporting their boxes, Liberal, Kansas

El Dorado Springs, Missouri

Macks Creek, Missouri

The same old grind, McAlevy's Fort, Pennsylvania

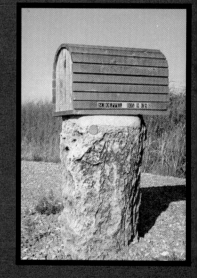

A piece of the rock, Fairview, Oklahoma

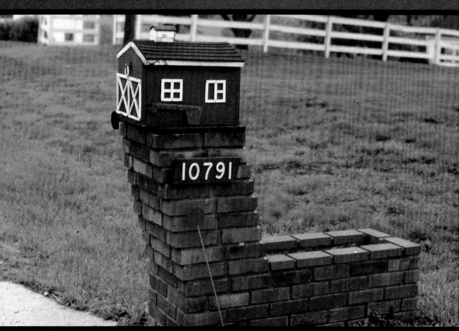

10791

Union, Kentucky

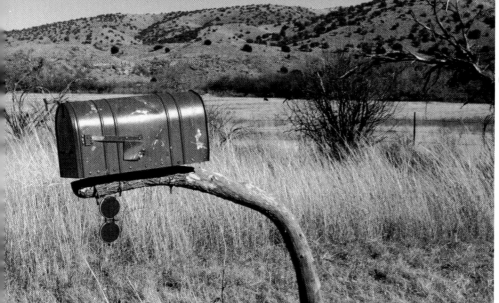

Supporting Roles!

A surprising array of materials in some pretty unusual forms have been put into service supporting the U.S. Mail! The variety is endless!

Patagonia, Arizona

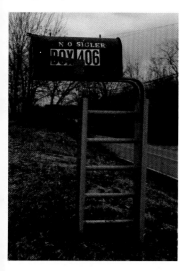

Berkeley County, West Virginia

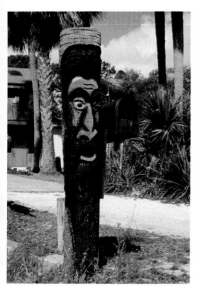

Carved palm trunk, Cocoa, Florida

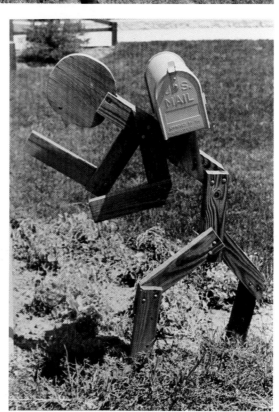

Williamsport, Pennsylvania

Springfield, Wisconsin

Etowah County, Alabama

Idaho Falls, Idaho

79

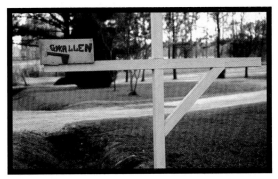

Elaborate woodwork at Wynn, North Carolina

Hendersonville, South Carolina

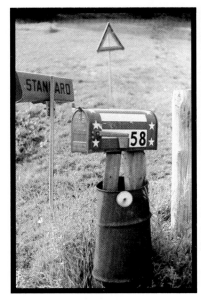

White Deer, Pennsylvania

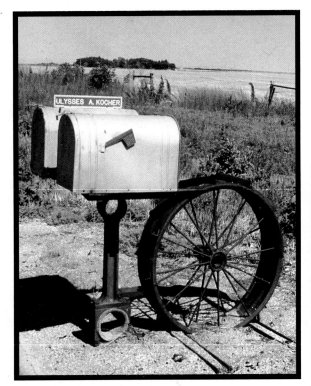

Stafford, Kansas

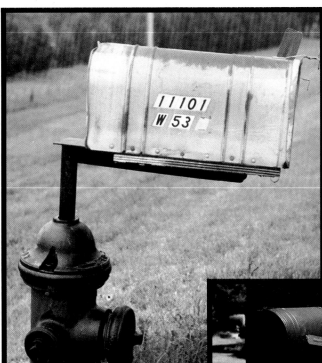

Fire hydrant in Maize, Kansas

This post has a lot to support! "Horno" bread oven box, Seton Village, New Mexico

Pawnee, Oklahoma

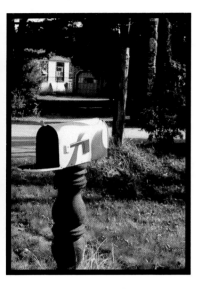

Coventry, Rhode Island

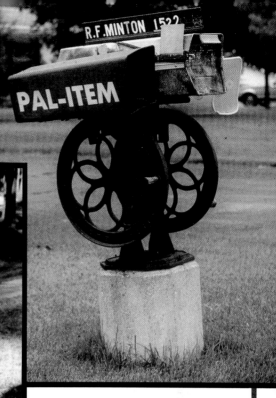

Antique coffee mill, Centerville, Indiana

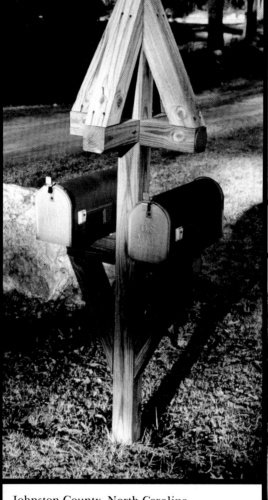

Johnston County, North Carolina

Nooseneck, Rhode Island

On the Old Santa Fe Trail, New Mexico

Northwest Georgia

Letterbox Letters!

 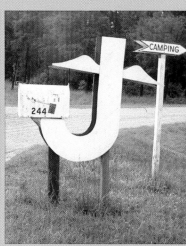

Above *(left to right):* Lanarck Village, Florida; Allens Corner, Illinois; Carrabelle, Florida; Gotham, Wisconsin

An alphabetical array of chainwork, pipe, and cut-out initials distinguishes these rural boxes.

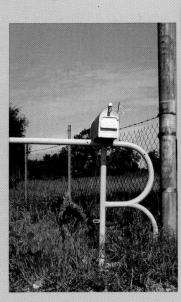 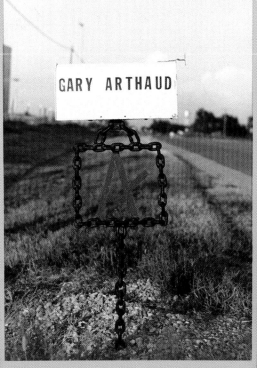

Above *(left to right):* Weaubleau, Missouri; Seiling, Oklahoma; Duck Springs, Alabama

Chain Gang!

West of Fairview, Oklahoma

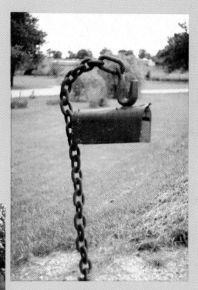

Nevada, Missouri

Chain and railroad spikes,
Salina, Kansas

Walterboro, South Carolina

Maize, Kansas

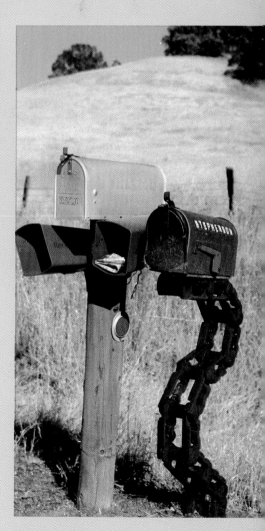

Bella Vista, California

Right: Michigan/Indiana state line *(top)*; Balls Mills, Pennsylvania *(bottom)*

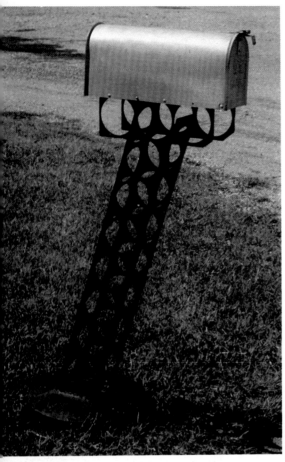

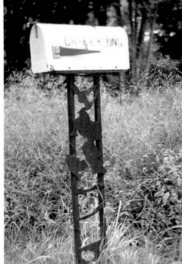

Midway, South Dakota

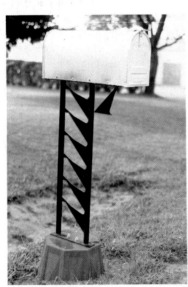

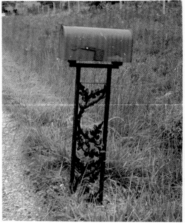

White Pigeon, Michigan

Preston, Missouri

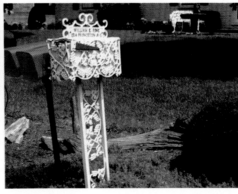

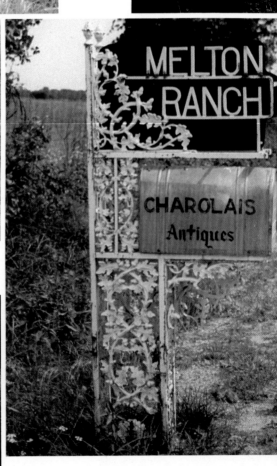

Williamsport, Pennsylvania

Above: Hammondville, Alabama *(top)*; Dade County, Georgia *(center)*; Mt. Vernon, Missouri *(bottom)*

Forged In Flame!

Forging, welding and casting produce distinctive and artful mailbox bases.

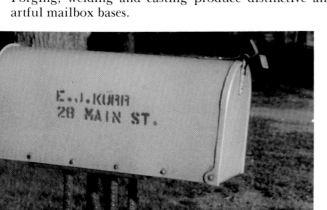

Oak Creek Canyon, Sedona, Arizona

Sturbridge, Massachusetts

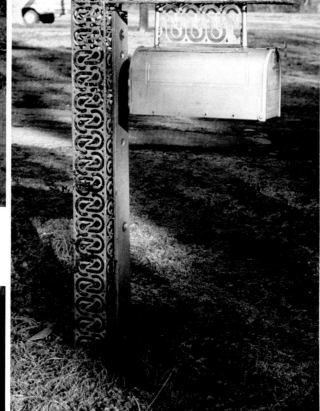

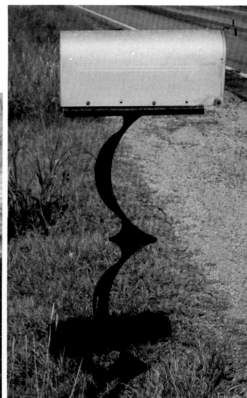

East of Perry, Oklahoma

Arundel, Mississippi

Strongbox, Gillett, Pennsyl-
vania

Fairview, Oklahoma

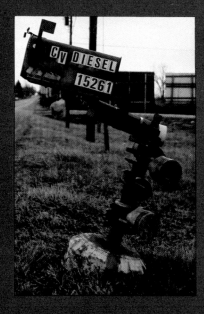

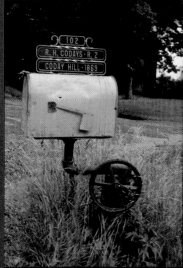

Augusta, Kansas

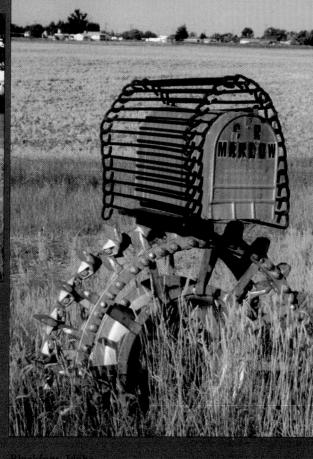

Blackfoot, Idaho

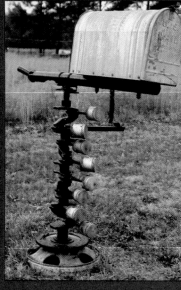

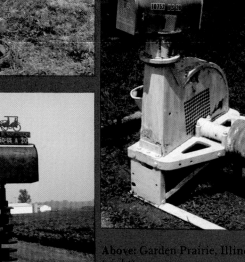

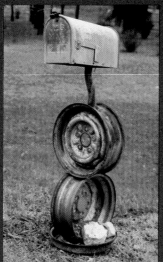

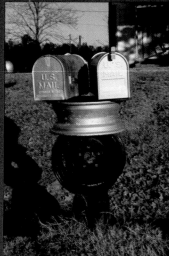

Above: Garden Prairie, Illinois *(left)*; DeKalb County, Georgia *(center)*; Four Oaks, North Carolina *(right)*

Above: Mason-Dixon line, Maryland-Pennsylvania *(top)*; Hammondville, Alabama *(center)*; Burlington, Ohio *(below)*

The site of the first train robbery by Jesse James gang, July 1873, on the Rock Island Line near Adair, Iowa

Mailbox Mechanics!

Crankshafts, pistons, gears and gizmos!

A muffler man *(below)* awaits the mail in Loveland, Colorado

Pawnee, Oklahoma

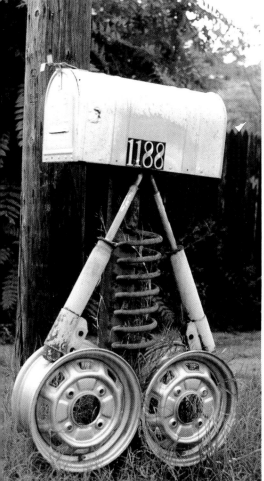

Sandersville, Mississippi

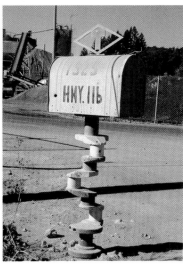

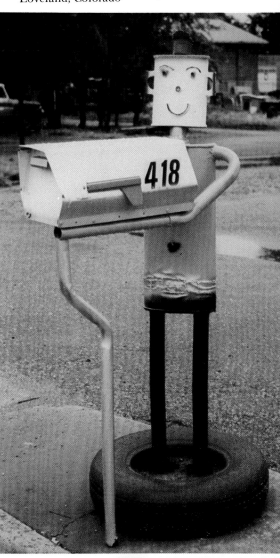

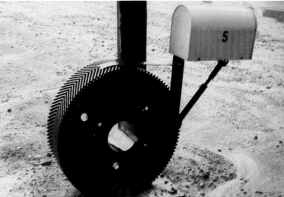

Cottonwood, Arizona

Forestville, California

Liberal, Kansas

At least 86 men were hanged from Judge Isaac Parker's gallows, Ft. Smith, Arkansas.

Roofing truss *(below)*, Nevada, Missouri

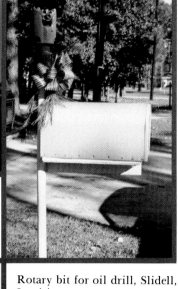

Rotary bit for oil drill, Slidell, Louisiana

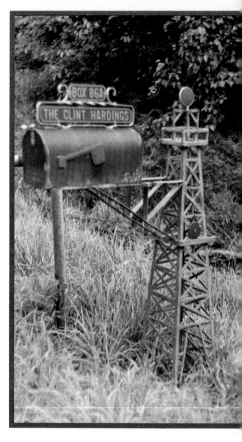

Model oil well, Augusta, Kansas

Working windmill, Deming, New Mexico

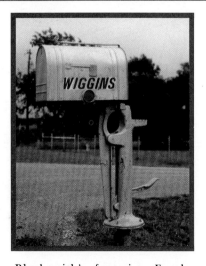

Blacksmith's foot-vise, Eureka, Kansas. Mr. Wiggins shoes three horses a week and also creates mailbox bases for his customers, using old pipes and chain.

Coal scoop, West Chester, Pennsylvania

Conquistador's weapon, northern New Mexico

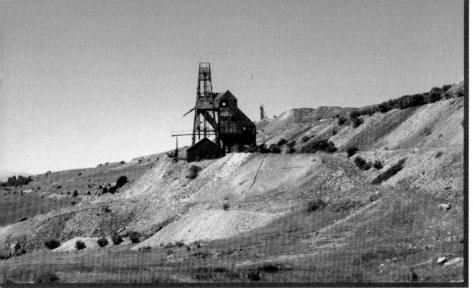

Old gold mines on Battle Mountain, Victor, Colorado

Tools of the Trade!

What's my line? Some mailboxes reveal clues about owners' occupations and interests!

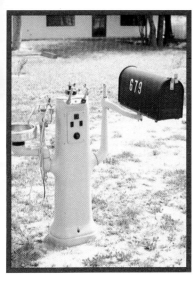

Dentist's drill, Oak Hill, Florida

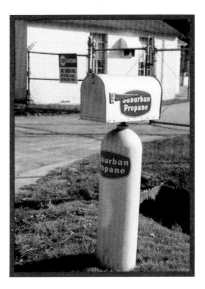

Bottled gas tank, Kent County, Rhode Island

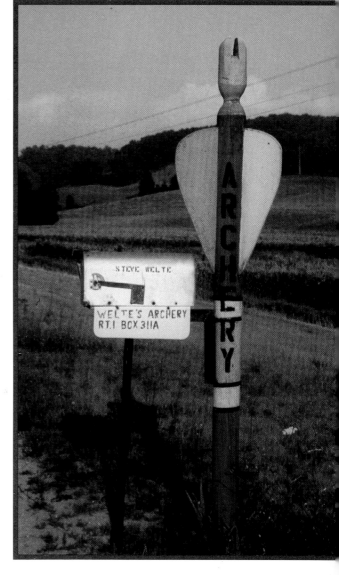

Embedded arrow, Boaz, Wisconsin

Baseball and catcher's mitt, Somerset, Massachusetts

Brass bed, Waverly, Virginia

89

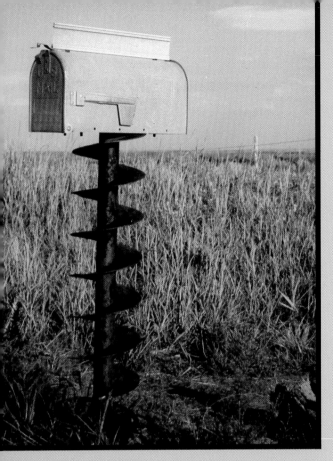

Vici, Oklahoma

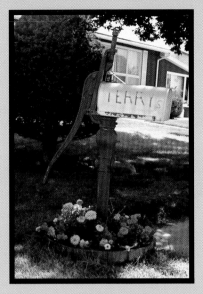

Valentine, Nebraska

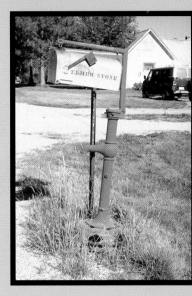

Victor, Idaho

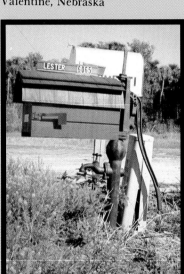

South of Rockledge, Florida

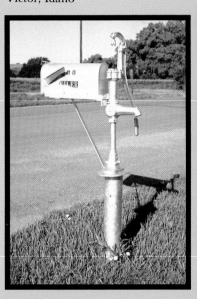

Manowi, Nebraska

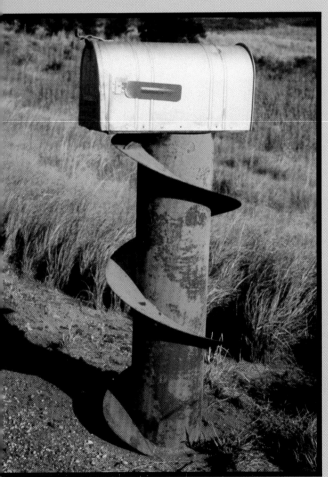

Orieta, Oklahoma

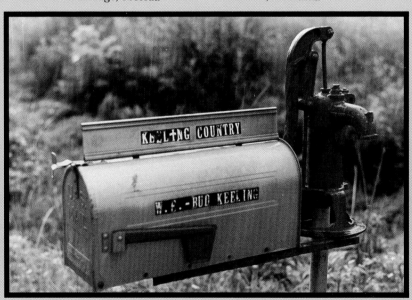

West of Kingman, Kansas

San Rafael Reef, west of Green River, Utah

A Long Way to Water!

Hand pumps and drills are popular mailbox bases, especially in the arid West.

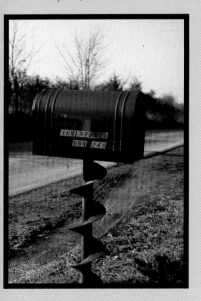

East of Peyton, Colorado

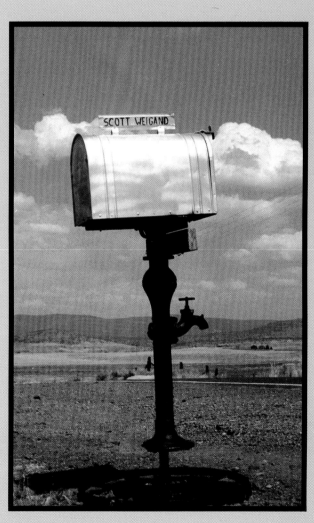

Willow Creek, California

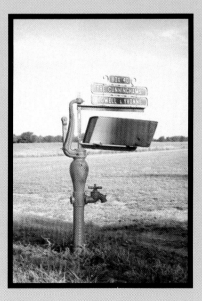

Rockingham County, Virginia

Major County, Oklahoma

91

Changing seasons in New England! The same
box in spring and in winter, eastern Connecticut

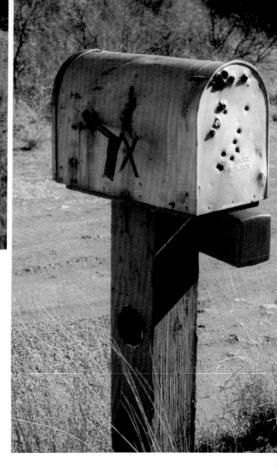

A constellation of bullet holes marks this Western
ranch box near Bowie, Arizona

School mailboxes can
take some hard knocks;
Middle School, Falcon,
Colorado

When landscaping gets out
of hand! Painted Post, New
York *(above)*; Homestead,
Florida *(left)*

Waiting for mail can
be deadly boring!
Lycoming County,
Pennsylvania

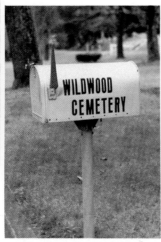

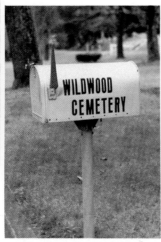

Above *(left and right):* Hit-and-run, fore and aft, Putnam, Connecticut

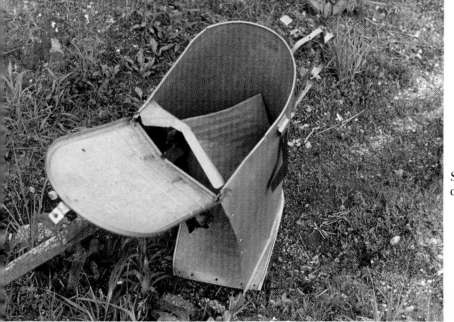

It's a Tough Job!

Standing close to the highway can be dangerous!

Coming apart at the seams, near Holts Summit, Missouri

After a hard game of "mailbox baseball", west of Guyman, Oklahoma

Bristow, Nebraska

Out of service, Sunlight Basin, Wyoming

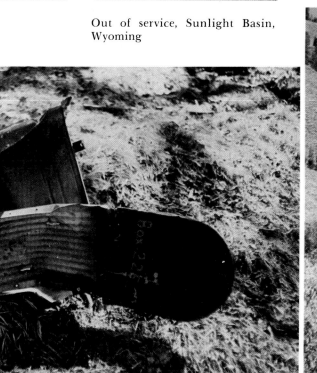

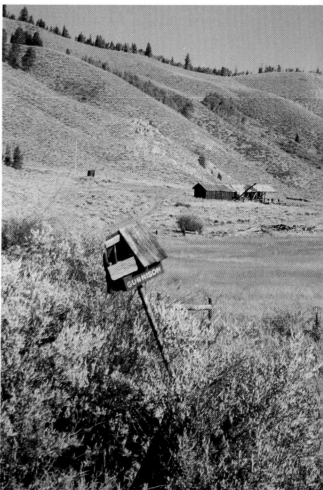

Abandoned! Sargents, Colorado

For Junk Mail Only!

There's nothing fancy about these receptacles!

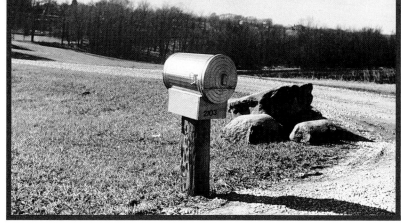

Jim DiMaio is making a statement in Indianola, Iowa.

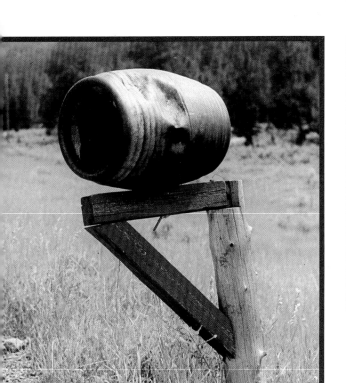

Sunlight Basin, Wyoming

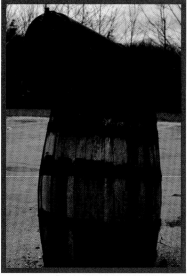

Over a barrel, near Chattanooga, Tennessee

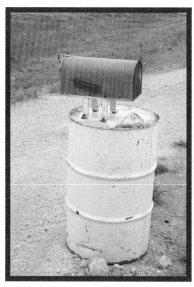

Felt, Oklahoma

Sunlight Basin, Wyoming

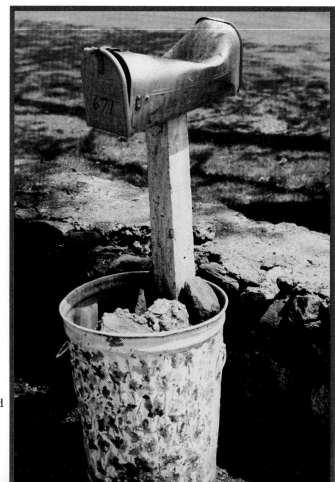

Narragansett, Rhode Island

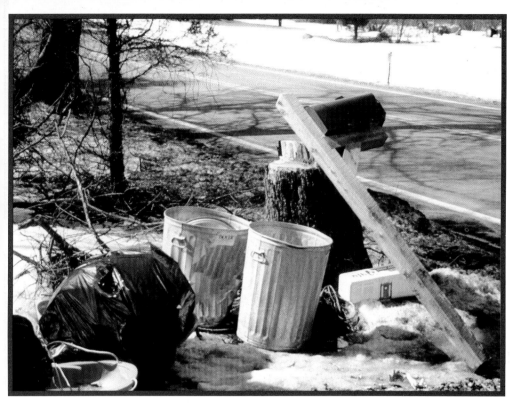

Coming or going? Colesville, New Jersey

Mailboxes
on the Move!

We spotted this uprooted mailbox in the Ozarks, at Cedar Springs, Missouri.

P.S., The Last Word!

Matunuck, Rhode Island

Waterville, Pennsylvania